E DUE

PATRICK WHITE

PATRICK WHITE

THE LATE YEARS

William Yang

MACMILLAN
Pan Macmillan Australia

First published 1995 in Macmillan
by Pan Macmillan Australia Pty Limited
St Martins Tower, 31 Market Street, Sydney

Copyright © William Yang 1995

National Library of Australia Cataloguing-in-Publication data:

Yang, William, 1943–
Patrick White : the late years.

ISBN 0 7329 0824 8.

1. White, Patrick, 1912–1990 - Biography.
2. White, Patrick, 1912–1990 - Portraits. I. Title

A823.3

Designed by Sandra Horth
Printed in Singapore by Kyodo Printing

CONTENTS

INTRODUCTION

You couldn't just *be* Patrick White's friend. Many had this desire and were cruelly snubbed. He had to *choose* you.

I would call myself a friend of Patrick White's and since he died I have wondered how I got in his door.

Jim Sharman introduced me in 1977. Jim at the time had rediscovered Patrick White through his plays. He had staged a successful production of *The Season at Sarsaparilla* for the Sydney Theatre Company at the Opera House in 1976. Prior to this, Patrick had some bad experiences with productions of his plays and he had stopped writing them. When Jim dragged Patrick's plays out of the mothballs of obscurity it started a new creative burst of play writing. Patrick was getting on in years and he said that he liked writing plays – the machine-gun attack of dialogue he found easier than the grind of novels.

Patrick met Jim's theatrical set of friends and they became his friends. He had a fondness for this younger generation and he wrote in his memoir *Flaws in the Glass* that he regarded them as his children.

Before I met Patrick, Jim had already taken him to an exhibition of mine, *Sydneyphiles*, at the recently opened Australian Centre for Photography. My work depicted the Sydney social scene and was something of an attack in that it often showed socialites posturing, grovelling and generally looking their worst. Part of the exhibition showed the gay community with implied and explicit gay eroticism. It was the first time in Sydney that this community had been depicted and it was considered controversial. Patrick had liked the exhibition. He bought two photos: a large one of Jim at Bondi and a small one of Kate Fitzpatrick.

So the fact that he admired my work, and that I was a friend of Jim's, was a good introduction to Patrick. Moreover I was gay. This was not a prerequisite for friendship, but it helped. I guess from there he must have liked me, as well.

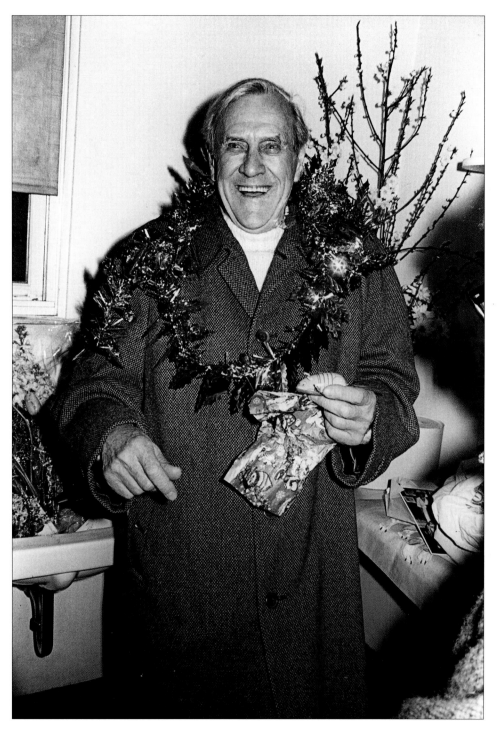

Patrick White. Parade Theatre, 1971.

BIG TOYS

I first met Patrick White after a performance of his play *Big Toys* at the Parade Theatre. Jim Sharman, who directed it, had invited me backstage where he hinted there could be a photo opportunity. As far as photos were concerned, everyone treated Patrick very gingerly. I had heard stories that he hated journalists and ate photographers for breakfast so being there was quite nerve-racking.

Brian Thomson had done the sets for the play. While he was researching, Patrick had shown him some scrapbooks that Patrick had put together as a child. They contained photos of the Royal Family. When one was opened, a letter that six-year-old Patrick had written to Santa Claus fell out. It read:

> *Lulworth, Xmas 1918,*
>
> *Dear Father Xmas,*
>
> *Will you please bring me, a pistol, a mouth organ, a violin, a butterfly net,*
> *Robinson Crusoe, History of Australia, some marbles,*
> *a little mouse what runs across the room.*

On the back it continued:

> *I hope you do not think I am too greedy but I want the things badly.*
>
> > *Your loving*
> >
> > *Paddy.*

Later, Patrick showed this card, along with another card addressed to the Easter Bunny with a similar long list of requests, to Jane Cameron, the agent. Brian and Jane conspired to buy these presents and put them in a pillow slip embroidered with the name *Paddy*.

When I first saw Patrick White he was in Kate Fitzpatrick's dressing room wearing silver holly Christmas decorations and he was opening a small parcel. Brian pushed me forward and said, 'Take that!' I seized my opportunity. It was beginner's luck. In all the following years that I photographed him I never saw him laugh so spontaneously as he did when he saw that little mouse.

Big Toys had corruption in Sydney society as its theme, and starred Kate Fitzpatrick as Mag, wife of QC Ritchie Bosanquet, played by Arthur Dignam. Max Cullen completed the *ménage à trois* playing the trade union man Terry Legge.

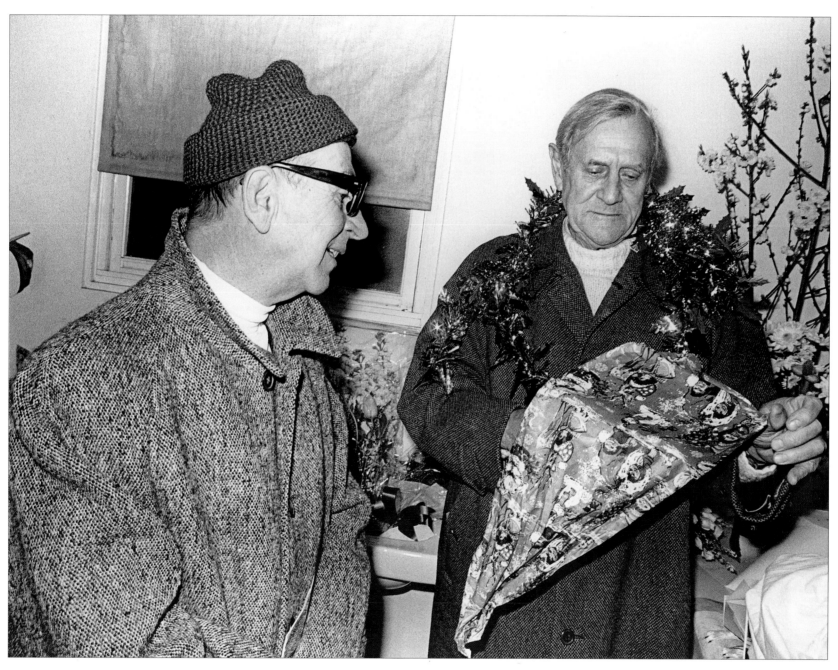

Manoly Lascaris and Patrick White. Parade Theatre. 1977.

Kate had already appeared in Jim's production of *The Season at Sarsaparilla* playing Nola Boyle, the wife of the sanitary man. Jim had liked her work – I would go so far as to say he was a complete stage-door johnny as he had a habit of falling in love with the leading ladies of his plays. Patrick had written the part of Mag Bosanquet especially for Kate and he had announced this at a New Year party at his place. Some time later he picked up the *Sydney Morning Herald* at breakfast to read that the night before, on the Royal Yacht *Britannia*, the Queen had dinner for about sixty guests including the Governor and Lady Cutler, the Premier and Mrs Wran, and Kate Fitzpatrick.

Being the Republican he was, Patrick went berserk. He immediately wanted to sack Kate. Jim had to hose him down and reluctantly Patrick agreed to let her do the part. During the rehearsals the relationship between Patrick and Kate was tense. He ignored her, he wouldn't talk to her, but after the previews he liked what she had done and he decided to forgive her. On the opening night he presented her with a huge spray of cherry blossoms and an 1887 signed etching of the English actress Ellen Terry as Beatrice with its printed inscription: *I would rather hear my dog bark at a crow than hear a man swear he love me* from *Much Ado About Nothing*.

Later that night, Patrick decided he wanted to go to dinner so Kate made a call to her friends at La Rhumba in Surry Hills to stay open. She and Patrick got a lift to the restaurant in a VW and, while she was struggling to get out of the back seat, Patrick said to her, 'Did I ever tell you about the night I had dinner with the Queen.' It almost caused her to drop the etching in the gutter.

I showed Patrick the photos I had taken both backstage and at the dinner and he liked them. Obviously he and Manoly hadn't had their picture taken together for many years because he ordered a bundle of that photo to send to their friends. Later he included both this and the one of him at the dinner, smiling with Kate, in his memoir *Flaws in the Glass*. Still later, he revised his rule regarding dinner with the Queen: you were allowed to have dinner with the Queen once, just to see what it was like, but not twice, oh no.

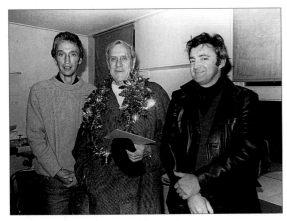
Arthur Dignam, Patrick White & Max Cullen.

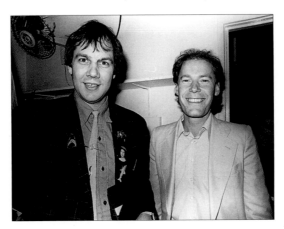
Brian Thomson & Jim Sharman.

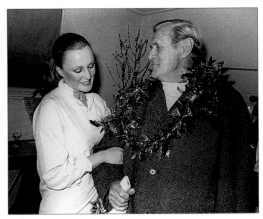
Kate Fitzpatrick & Patrick. Parade Theatre. 1977.

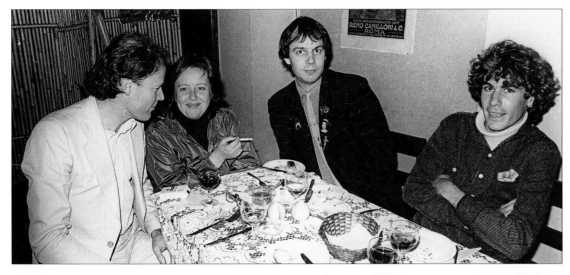

Jim Sharman, Jane Cameron, Brian Thomson & Jim Waites.

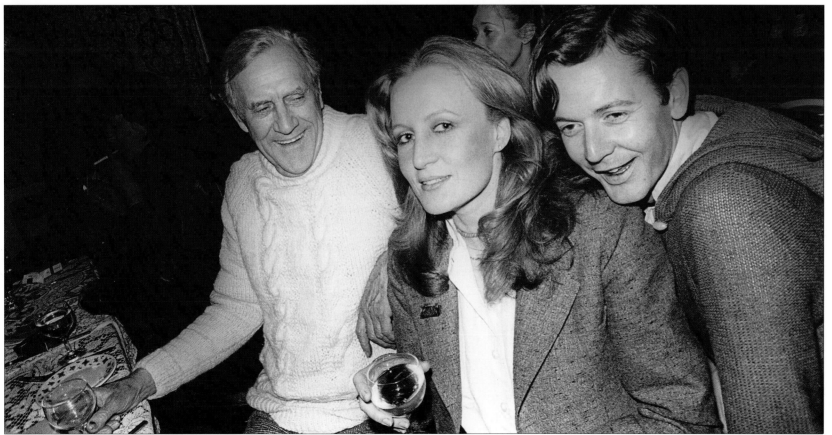

Patrick White, Kate Fitzpatrick & Robert Burton. La Rhumba Restaurant. 1977.

DINNER AT MARTIN ROAD

Shortly after the season of *Big Toys* Patrick rang me up and asked me to dinner.

His place on Martin Road faced the park. The large weatherboard house had a domestic feeling, it was not grand. Big gum trees dominated the yard. A steep walk up the tiered front garden led to the side entrance. I arrived on the dot of seven. Patrick opened the door and noted my punctuality.

I entered into an open corridor between two large spaces, the living room to the right and the dining area to the left. At the end of this wide corridor was Manoly's shrine where the gold backgrounds of the Greek and Slavic icons glinted in the dim lighting. The walls of the big rooms were crammed with paintings.

The works of stage designer Desmond Digby, who painted theatrical portraits of women usually in Edwardian costume with hats, dominated the collection. Works by nuclear scientist John Stockdale covered part of a wall in the dining room. His pieces – dots, dashes, squares and squiggles – read as coloured abstractions but were of specific things that he saw under the microscope. The third well-represented painter in the collection was Jim Clifford who painted in figurative designs of bright glossy enamel. There were a few Brett Whiteley paintings including one of a path leading into a billabong and another small work consisting of stones glued onto a red earth background decorated with a few lines and arrows of white paint.

The collection was totally eclectic and also included a collage by Martin Sharp made up of couples cut out of magazines and art books. There were abstracts by Stan Rapotec and Tony Coleing and a small, delicate composition by John Davis made up of twigs, string and a strip of canvas, depicting a country gate. A beachscape by Ken Searle, *Lamington Suicide*, showed angular boulders turning into huge square lamingtons, throwing themselves off a cliff into the sea. This visual sense of humour was again evident in a piece with a domestic flavour by Jenny Barwell comprising a set of wooden laundry pegs, daubed with paint, nailed and bound to a panel.

The main wall of the living room was hung with a large painting by Victor Rubin which I can only describe as extremely confrontational. It depicted an arena of people in some sort of nuclear shelter. The closer figures were presented as something after the mood of Francis Bacon: figurative deformities, humans disintegrating, presumably after a nuclear disaster. Found objects such as a Coke can, parts from transistors and bits of rubbish were pasted into the painting. The background fence was defined by peeling billboards advertising Mortein, Coca Cola and cigarettes.

I mentioned in conversation that I came from Brisbane, whereupon Patrick embarked on a long list of names of all the people he knew there. 'Do you know the so-and-so's?' I knew none. I had that sinking feeling of getting nought in an examination.

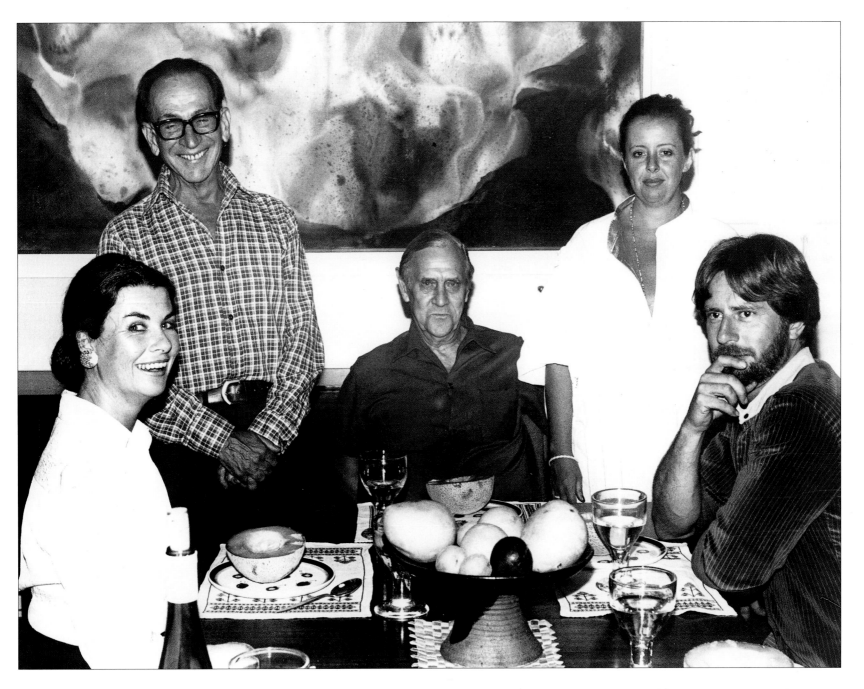

Robyn Nevin, Manoly Lascaris, Patrick White, Jane Cameron, Rex Cramphorn. Martin Rd. 1978.

I was saved by the arrival of actress Robyn Nevin, who was the guest of honour, agent Jane Cameron and theatre director Rex Cramphorn. Seven years prior to this, Robyn, Rex and I had been involved in a season of plays produced at the Jane Street Theatre in Randwick. Patrick alluded to this season, and said he never thought then that we would ever be sitting together at his dinner table.

He liked cooking at home, he confided, and when the subject of kedgeree came up he gave us the recipe. Basically it was a dish of leftovers eaten at breakfast. Robyn had played Girlie Pogson in *The Season at Sarsaparilla* in which she had the line, 'I'd have given my hair for a dish of kedgeree.' Patrick also gave us a recipe for faggot, an English dish made of suet, minced pork and bay leaves stuffed in sheep's belly and baked in the oven. Fortunately, he did not serve this to us. He served spinach spanakopita, but not from the table. He got up to serve from a baking dish on the sideboard. Manoly assisted. Patrick placed the food onto the heated plates and Manoly transferred them to the table with a gloved hand. Manoly had a great virtue: he was patient. Patrick was not.

After dinner, Patrick took Robyn to his study where his gift for her, a drawing by George Baldessin, leant against his work desk. Robyn said that she felt awed by being in the room where Patrick wrote; this feeling overrode any sense of pleasure at receiving the gift. In any case she liked the gift, which was a charcoal drawing of a woman's head – a witchy creature, rather sad and wild looking, with lots of hair. Patrick said it reminded him of her.

The study walls were stacked with more personal paintings of a smaller scale. Jim Clifford's work depicted a naked man lying on his stomach. It was not an overt nude – the form was subtle and the naked buttock was obscured by a splash of paint. A small Desmond Digby showed Patrick in drag wearing a big Edwardian hat tied with a bow; his companion, a pug, was dressed in similar costume. Another Digby was a six-panelled portrait of Melbourne socialite Margaret Carnegie. Margaret had commissioned the work but had not liked the result; understandably so, because it was not flattering. One of the panels showed her laughing with her mouth wide open, looking rather vulgar, and she had not bought it. Patrick, of course, had loved it. He had bought the piece and hung it in his study in order, one rather suspected, to spite Margaret.

My own work, a photographic portrait of Jim Sharman, depicted Jim in profile looking out of his unit at the sea. Below this image was juxtaposed another: the meal he had cooked that day – fried fish with three vegetables, very Australian. It was something of a joke, entitled *Bondi Delicious*. Patrick had previously told me he liked the picture because it reminded him of Jim creeping around the rehearsal room, but this time I must have stared at the photo too long because Patrick sighed and said that whenever the artists came to his place to see his collection they only ever looked at their own work.

We were all conscious of having dinner at Patrick White's, so things were a bit stiff. Rex later remembered the dinner as ghastly, but Rex was antisocial. Robyn didn't feel relaxed and Jane, who knew Patrick better than all of us, having been to his place several times, wrote in her diary that the dinner was 'not good'. In a perverse way I enjoyed it. I took some photos. They're a bit off. Nerves. I wondered if I would ever be asked back.

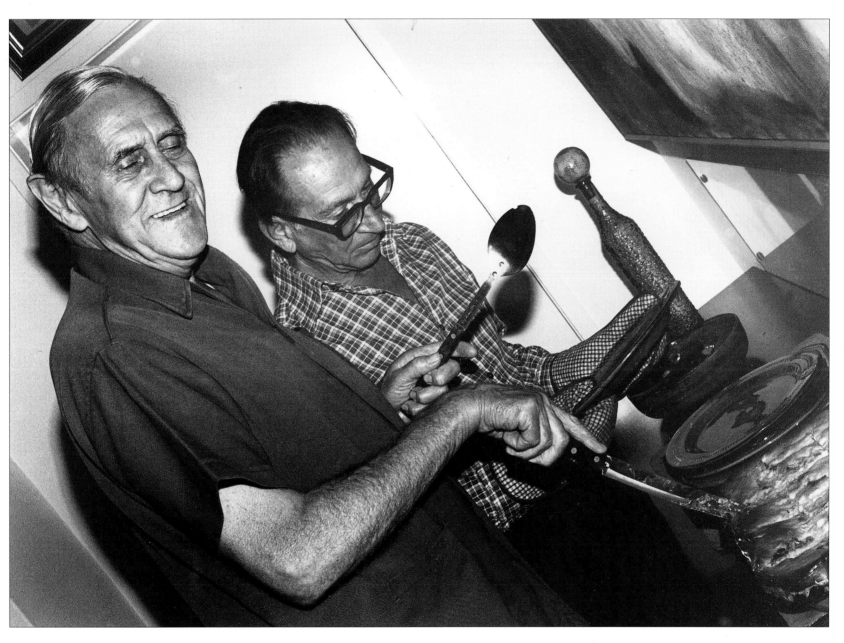

Dining Room. Martin Rd. 1978.

A few months later he asked me around again. He had also invited Jim Sharman, the painter Michael Ramsden and his wife, the fashion designer Jenny Kee. Jim set up this event so that Patrick could meet Michael who was emerging as a painter.

Michael is quite an expansive raconteur and he was able to keep the conversation flowing through the evening, so there were no long silences. He and Patrick got on very well. When Patrick took Michael upstairs to look at more paintings, Jenny felt that the girls had been left downstairs while the big boys – Patrick and Michael – talked about art upstairs. She and Manoly chatted about his operations in the kitchen.

I had brought along some photos which Jenny had ordered and I gave them to her. One showed her in a slightly provocative pose having spread her extensive printed skirt, revealing her legs. Patrick liked it. He said, 'It's a pity you weren't around to photograph me when I was kicking up my heels.'

At an exhibition of Michael's paintings at Watters Gallery, Patrick bought three: a large one of rosellas flying around a garden in the Blue Mountains, which he put above his desk in the study; a smaller one of an archetypal Australian male face in a digger's hat; and one of three children, one above each other, in a totem. The kids were Michael's relatives and they squinted in the bright Australian light. Patrick also bought another version of this, a drawing of the two boys, the older boy with his hands on the shoulders of the other. He was quite fond of this drawing which he often described as a picture of Jim Sharman as a boy with the brother he never had.

Before this exhibition Patrick went up to the Blue Mountains to preview Michael's major opus *The Night at the Kurrawong Palace*. This huge unfinished oil painting was based on a wedding photograph from the fifties. Michael had substituted some of the sea of faces with people whom he knew. Others he left as unidentified typically Australian faces. Patrick White was there seated at a back table by himself. Jenny Kee, as one of the three brides, chatted to an unidentified man. Jenny's father Billy Kee stared out from the centre of the painting, while her mother Neen laughed in the background. Linda Jackson turned away, while Clyte Jessop stared solemnly from the canvas. Michael's brother was there as a shy young boy. An Aboriginal waiter lurked in the background.

Patrick gave Michael the impression he would buy the painting, but when he saw it finished at the Watters Gallery exhibition he didn't like it as much and he reneged. Since he bought the three smaller works, Jim thinks he had committed himself to too many of Michael's paintings.

Then Michael made the mistake of mentioning in an interview that Patrick White had bought his work. It was probably an innocent remark but Patrick was very sensitive to what he perceived as someone using his name to promote themselves. He thought Michael should be put in his place and he cut him. Thus ended what Manoly described as 'the short, passionate affair with Michael Ramsden'.

Michael Ramsden

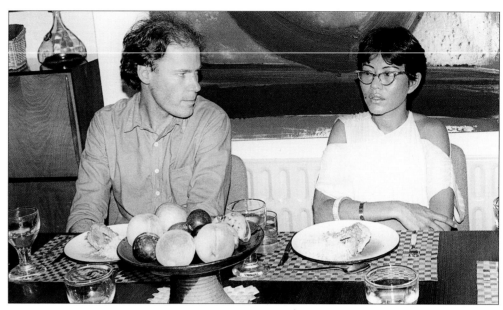

Jim Sharman & Jenny Kee.

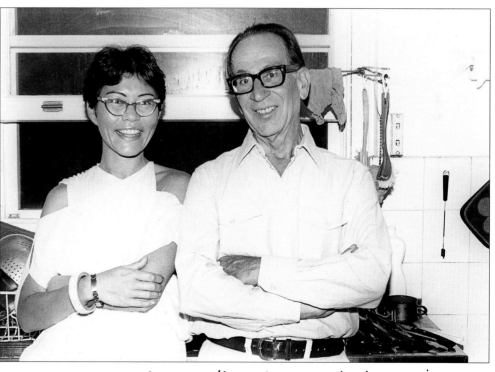

Jenny Kee & Manoly Lascaris.
Martin Rd. 1978.

THE STUDY

I took this photo of the study some time after Patrick died. The original desk and his typewriter had already gone to the Mitchell Library and a new desk of similar size had been brought in and was now used by Manoly but, by and large, the room looked like this while he was alive.

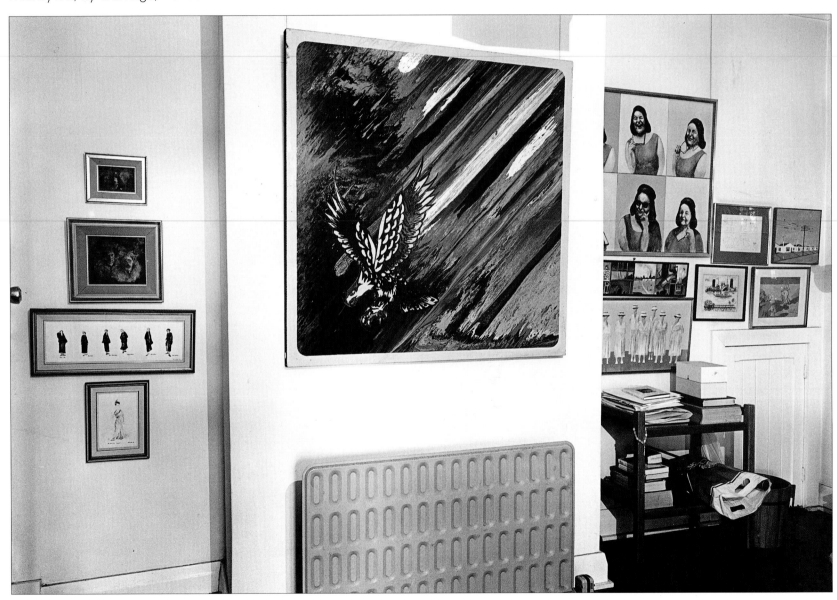

MANOLY'S SHRINE

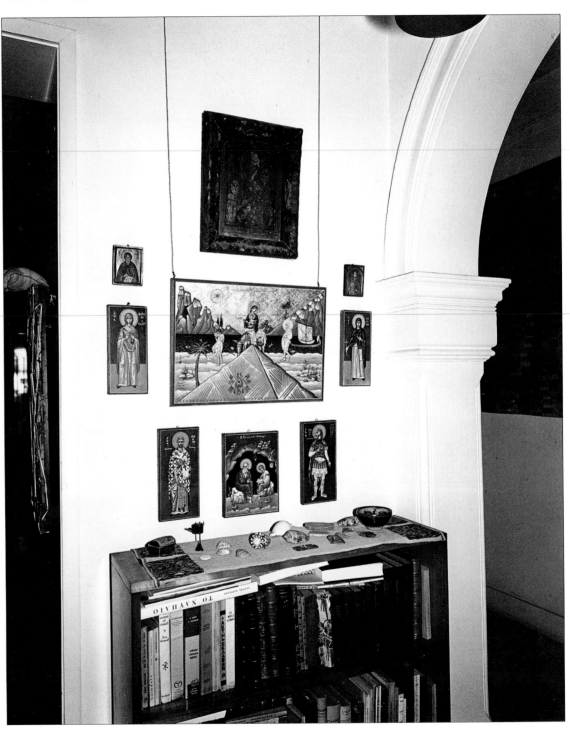

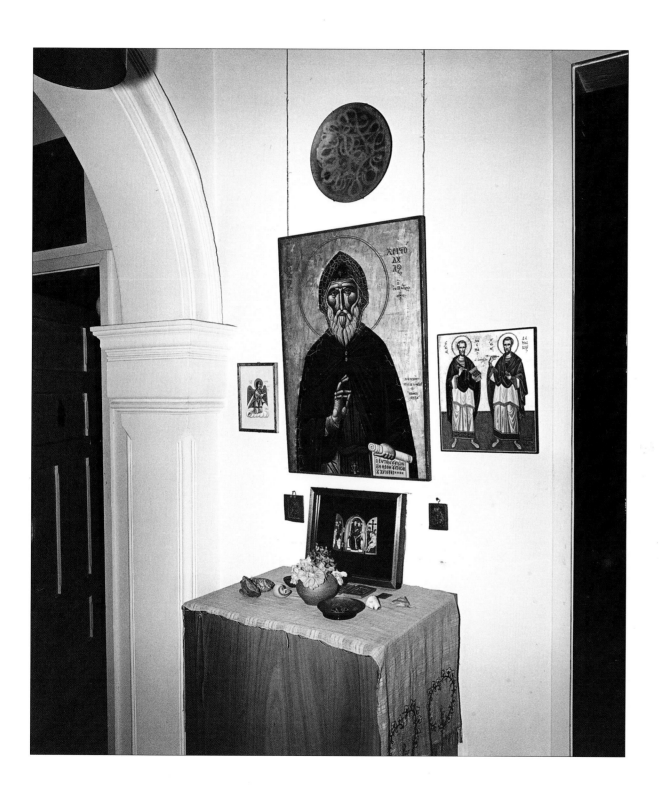

DINNER AT JIM'S

When he lived at Bondi, Jim Sharman gave a dinner. Jim, to my mind, was not one who entertained a lot. Fran Moore and Linda Jackson helped with the menu (spaghetti marinara). The guests were friends or people who worked with Jim in the theatre or films. These included three music composers: Richard Meale who composed *Voss*, the opera, Ralph Tyrrell who did the music for *Pandora's Cross* and Cameron Allen who did the soundtrack for *Summer of Secrets*.

Patrick was the unofficial guest of honour. He enjoyed himself and there were no shouting matches or tears for which, at dinners, he was famous. Consequently no one remembers a thing about it. Jim only remembers that this was the largest number of people he ever had at his place. Margaret Fink had just met Bill Harding so she only remembers him. Jane Cameron, who had sunburn, remembers nothing as she slept through most of the evening. Patrick remembered something: he met Mandy Barrett for the first time and she told him that she had 'a bladder as small as a pigeon's egg' and this often-repeated detail was something he never forgot.

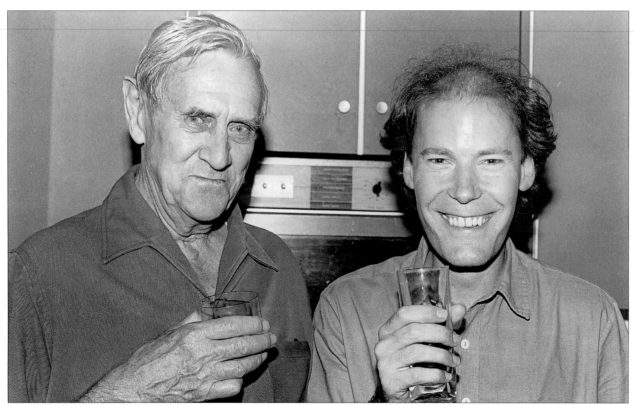

Patrick White & Jim Sharman. *Bondi. 1978.*

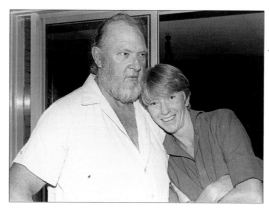
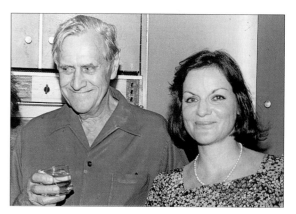

Patrick & Richard Meale.

Morv Lilley & Fran Moore.

Patrick & Margaret Fink.

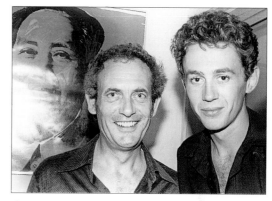

Mandy Barrett.

Basia Bonkowsky.

Bill Harding.

Richard Meale & Cameron Allen.

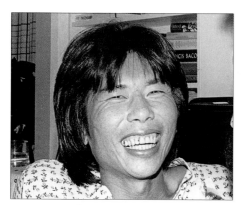
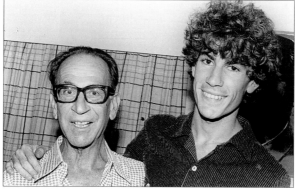
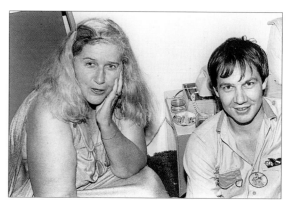

William Yang.

Mandy Lascaris & Jim Waites.

Dorothy Hewett & Brian Thomson.
Bondi 1978.

THE NIGHT THE PROWLER

Jim Sharman's film *The Night the Prowler* was taken from a short story of Patrick's which was first published in *The Cockatoos*. Patrick did the screenplay. The story concerned a teenage girl, Felicity Bannister, living with her overbearing mother and ineffectual father in a suburb around Centennial Park. One night a prowler breaks into her room. She hints she has been violated, although later we find that was not the case. After this event she goes on a rampage in the neighbourhood breaking into people's houses, destroying things. It's an overreaction; she's rebelling against the social situation she was brought up in: the restrictive Australian way of family life. During these rampages she gets glimpses of what people are really like and this stabilises her. Finally, in a deserted house, she finds an old derelict, naked and dying. She sees the human form at its most defenceless and squalid, stripped of any sense of human pride. In this moment she comes face to face with some sort of truth and it brings her down to earth and calmness.

Luciana Arrighi did the designs and David Sanderson was the cinematographer. The publicist, Fran Moore, let me on the set a couple of times, not to take the still photos, which were taken by Brett Hilder, but to take specialist social photos. I wasn't paid as it was regarded as a photo opportunity for myself; the film was considered a big event in our circle.

The main location was a house at Vaucluse which was rented while the owners were away on holidays. A tragic real-life scenario, which was not dissimilar to the situation of the Bannister family, had already been played out in those rooms. The daughter had committed suicide – she shot herself. This fact was whispered around the set by everyone from the leading lady to the best boy. It was considered that the house had a suitable vibe for the film.

When I first arrived, the street had been partially blocked off and neighbours were very interested to know what was happening, without being so forthright as to be openly curious. Two party scenes were to be shot that night. The first was Felicity's twenty-first birthday. A host of young extras, Felicity's friends, were being made-up and dressed in party frocks and suits from the fifties.

They shot the scene in the backyard and the place dripped with lanterns and coloured lights. A table of food caught my eye: lamingtons, cake, sausage rolls and asparagus wrapped in bread. I moved a plate to compose a shot. Luciana told me not to move things as it might disrupt the continuity. It was the first time I'd been on a movie set.

The choreographer Keith Bain rehearsed a dance number with Ruth Cracknell, who played Felicity's mother. One of the dressers squeezed Kerry Walker, who played Felicty, into a party dress. At twenty-nine Kerry was ten years too old for the part, but Patrick had chosen her over all the other girls who did screen tests.

When I had a short chat with Jim he told me excitedly that Patrick had just decided on a name of the house for

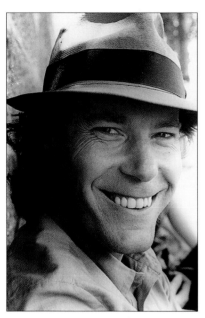

Jim Sharman.

Kerry Walker.

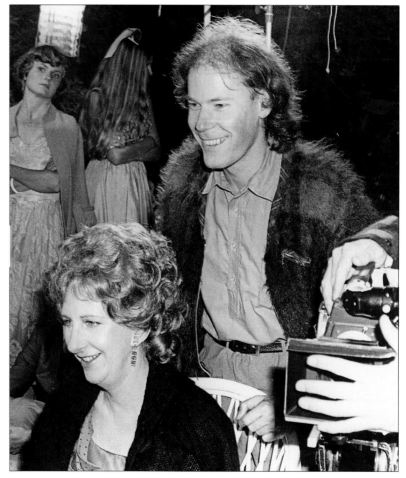

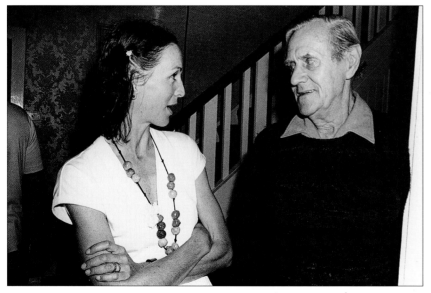

Luciana Arrighi & Patrick White.

Ruth Cracknell & Jim Sharman.
Vaucluse. 1978.

21

the movie, 'Tintagel', and that the art department was at that moment making a sign of the name for the front garden. I looked blank so Jim explained to me that it was the name of the castle in Cornwall where Isolde waited for Tristan. Jim was really chuffed about this so I feigned excitement too.

Later that night they shot the second party: a gathering of friends at the Bannisters' home. The roles were for older people and Jim had assembled an array of Sydney characters whom he thought should be recorded. Doris Fitton, who ran the Independent Theatre for many years, and Alexander Archdale, a well-known character actor, were cast as guests along with Maggie Kirkpatrick who had then not achieved the fame she was to receive for playing the role of The Freak in 'Prisoner'.

Patrick spent most of the night in the dressing room of the actresses. Like every writer, he loved to hear actors gossip. It was decided that since Doris Fitton was on the set she should have a line, so he made one up on the spot: 'Times have changed. In the old days on the Orient Line it was "white ladies" every night for most of the gels.' It was explained to me that a 'white lady' was a drink. Doris spent the rest of the night practising her line as if she were going to project it in a large theatre.

I knew Doris had a history in Australian theatre and, ever mindful of a publicity shot, I put her and Patrick together for a photo. Although he did not object at the time, Patrick was not amused by this incident. Later I learned that Doris, when she ran the Independent Theatre, had kept the script of Patrick's play, *The Ham Funeral*, in her drawer for nine years, always thinking of doing a production but never getting around to it. She was not his favourite person.

Much later at an Adelaide Festival I tried again to throw Patrick together with another celebrity, Margaret Whitlam.

'No,' he said, fixing me with his fiercest stare. 'It's not that I don't like Margaret, I like Margaret very much, but photographers are always throwing this person up against that person. It's a photographic cliché.'

'Isn't that the game?' I ventured lamely.

'You can do better than that,' he pronounced. Then he stared off, as was his habit, into the middle distance. The discussion was closed.

Jane Cameron came over and saved the situation.

'Then do you mind if I take your photo with J-Jane?' I asked, trying to sound casual but somehow stammering.

There was a pause and I wondered if I had added insult to injury. But no, he was perverse.

'No. I don't mind having my photo taken with Jane,' he said agreeably.

I remember one other incident from the making of the movie. Jim came on the set one day and said, 'Patrick just had a screaming session.'

'Oh,' I said.

'Yes. He screamed. He was totally out of control but he's calmed down now. He got over it quite quickly.'

'What was it about?' I asked.

'I brought in the design for the poster from Greater Union. It read: THE NIGHT THE PROWLER BY PATRICK WHITE, WINNER OF THE NOBEL PRIZE. He screamed.'

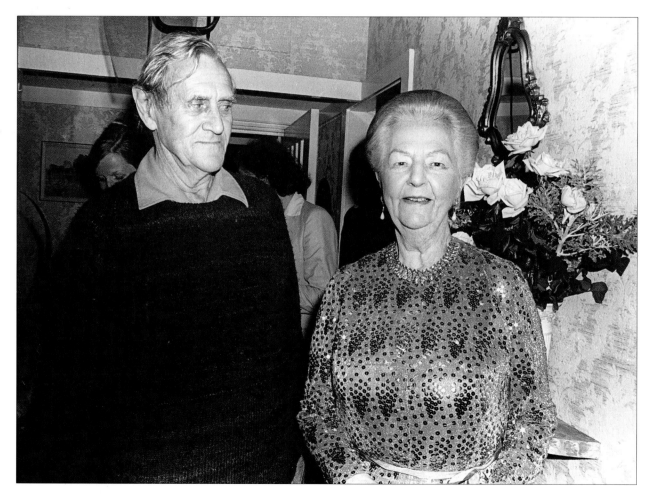

Patrick White & Doris Fitton. Vaucluse. 1978.

PARIS THEATRE

Patrick gave a speech at the launch of the Paris Theatre Company, a breakaway Sydney theatre company led by Jim Sharman. It was the intention of the company to perform *A Cheery Soul* as their third piece after productions of Dorothy Hewett's *Pandora's Cross* and Louis Nowra's *Visions* but the company folded after these two performances.

I never got to see any of these productions as I got sick with hepatitis and was away for almost a year. When I had just been diagnosed, Patrick heard about it and one day he rushed over in a taxi with a food parcel: a barbecued chicken, a can of spinach, a jar of English marmalade, some chocolate and a packet of shortbread biscuits – all in David Jones' wrapping. It rather reminded me of a Second World War food parcel to the troops. Unfortunately he hadn't rung first and I was away seeing a doctor but my friends, with whom I shared the house, were very impressed by his visit and by the fact he wore an overcoat although it was not cold.

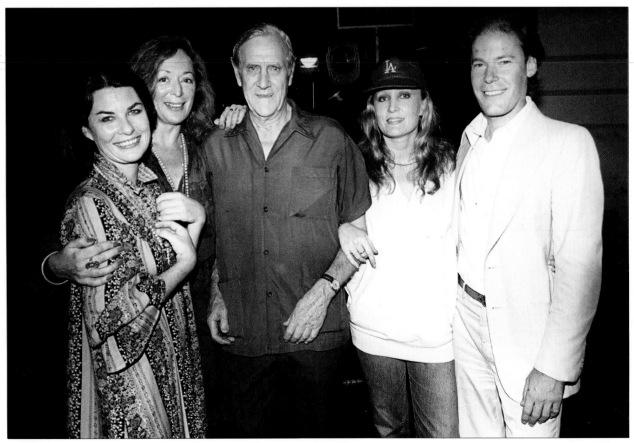

Robyn Nevin, Jenny Claire, Patrick White, Kate Fitzpatrick, Jim Sharman.
Paris Theatre. 1978.

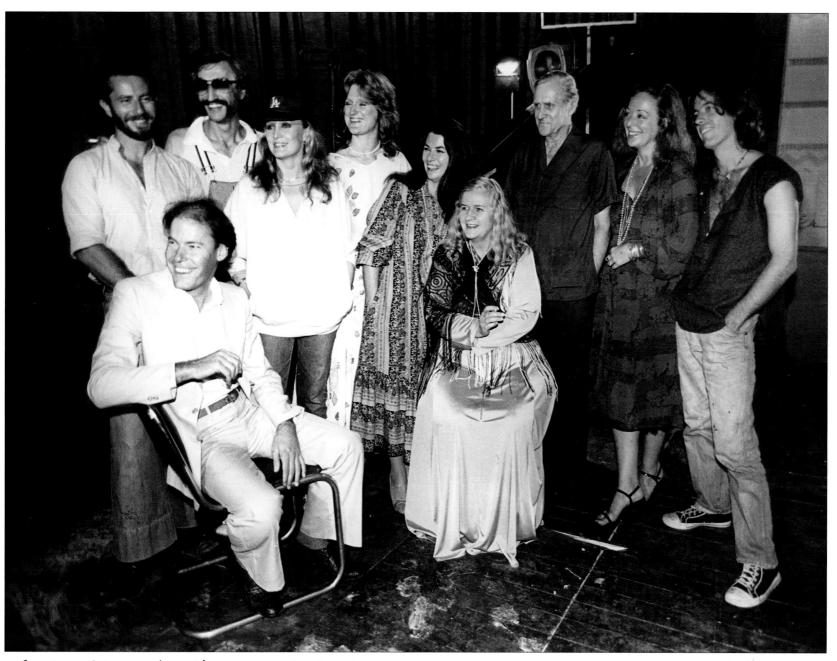

Rex Cramphorn, Jim Sharman, Arthur Dignam, Kate Fitzpatrick, Julie McGregor, Robyn Nevin,
Dorothy Hewett, Patrick White, Jenny Claire, Neil Redfern.
Paris Theatre. 1978.

THE BRETT WHITELEY SESSION

I was sick with hepatitis for almost a year. I stayed in Brisbane. During this time I had a correspondence with Patrick but later the letters were burnt in a fire which also destroyed some of my negatives.

I came back to Sydney but still felt a bit weak. Brett Whiteley rang me one day and asked if I would take some photos of Patrick. He was at Kate Fitzpatrick's. He explained he wanted to paint Patrick's portrait. I think in some way the Archibald Prize was implied although it was not an issue. He asked if I could come around straightaway. I said yes.

Kate had set up the lunch for Brett to meet Patrick. Although Patrick had purchased many of Brett's paintings he had never met him before. Manoly was there, as were Wendy Whiteley and the painter Joel Elenberg, who was a good friend of the Whiteleys'. Joel's hair had fallen out as he was receiving chemotherapy for a recently diagnosed cancer.

Brett didn't give me any instructions for the photos; he left it entirely up to me. He and Wendy left shortly after I arrived. This was the first time I had a chance to photograph Patrick in a session situation, where he was captive, so to speak. At other times it had been done on the run, at parties or dinners where the social situation allowed only a quick, fleeting encounter. Patrick was not difficult about having his portrait taken. I can't say he liked it; rather he endured it. He could not express himself like an actor, but then most people can't. I made no attempt to ask him to perform or even to smile, which is difficult for anyone and somehow it seemed inappropriate for him. Patrick in conversation about portraiture mentioned how important it was to portray the hands of the sitter, so I took my cue and did some with his hands.

Brett and Wendy returned so I also took a few social photos of the group, for myself.

Brett liked the photos. I've kept the proof sheet of his order. Of course he was visually astute, and he circled the parts of the photos that appealed to him. He had an ability to zero in on significant detail. No one else had ever looked at a proof sheet like he did.

At the time I had just taken up a job with *Mode* doing their social pages. It was a 'new look' *Mode*, and everything about it had been revamped. I showed the photos to my editor, along with a whole pile of other social photos I had taken. In the past *Mode* had social pages where a whole gathering of snaps would be laid out on the page, but the new editor didn't like that idea and concentrated on just the one photo, that of the lunch. I thought at the time that there could be trouble, but I was in a helpless frame of mind and did nothing about it.

When the new *Mode* hit the stands, Andrew Cowell, the publisher who had also hired me, was terribly pleased with the issue and he visited the Whiteleys with a copy under his arm. Andrew was like the

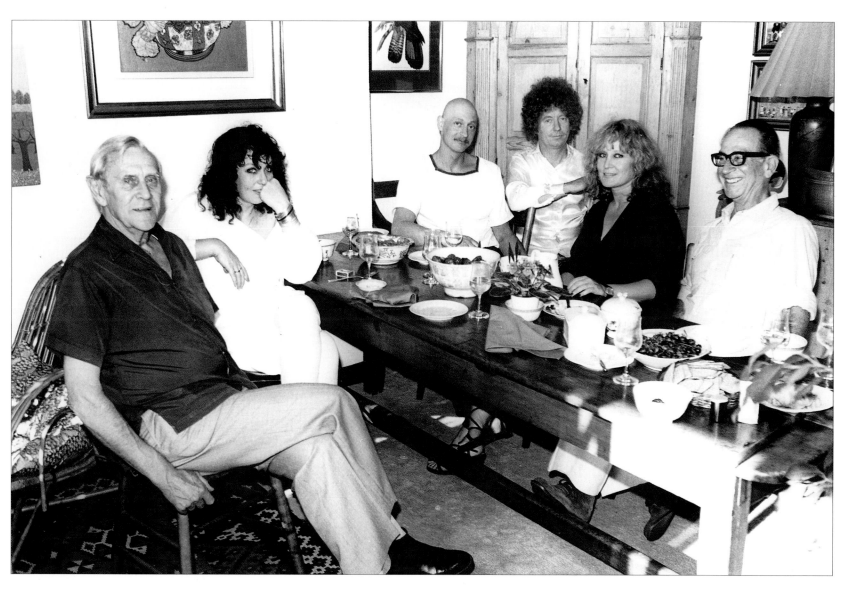

Patrick White, Wendy Whiteley, Joel Elenberg, Brett Whiteley, Kate Fitzpatrick, Mandy Lascaris.
Kings Cross. 1980.

messenger character in a Greek tragedy who thinks he is bringing good news to the principal actors only to find. . . The Whiteleys were not amused. They considered the photo an invasion of privacy, not for themselves so much but on behalf of Patrick, and they feared that this would cause a falling out between them. They wanted the issue shredded but it was too late; it had already gone out.

I was hauled over the coals for my unspeakable act and they demanded that I apologise to Patrick. So I wrote the worst letter of my life blaming the press for my bad judgement. Later I heard from another that Patrick had enquired after me, 'How's that smarmy Chinese photographer?' I had to look up the meaning of 'smarmy' in the dictionary, then I lay low for a year in disgrace.

The portrait did not end on a good note.

At one stage Brett asked Patrick if he would write down his loves and his hates on a piece of paper, more or less as research or inspiration for Brett. Patrick wrote the list. Brett incorporated the note in his work: he pasted it into the portrait so it sat on Patrick's desk held onto a board with a painted paper clip. When Patrick found out about this he was furious. He claimed the note was private and that Brett was dishonest in that he had given Patrick the assurance it was for Brett's eyes only. This incident was probably the last straw in a series of criticisms Patrick had built up about Brett. Among these was the perception that Brett sought too much publicity and that a real artist of stature did not need such self-promotion. These criticisms he put into a letter to Brett. Brett was in his turn furious about the letter. An angry reply was sent back to Patrick. They did not communicate again.

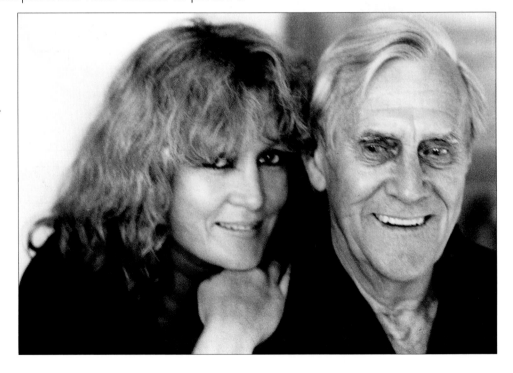

The offending note of loves and hates begins with *Loves*: *Silence with birdsong* and continues through various items, *Reading, Whisky, Sex, Pugs, The thought of an Australian republic, My ashes floating on the lake*. There is an equally long list of *Hates*: including *The PR machine, socialites, Writing, TV, News announcers, The overgrown school prefects from whom we never escape*. The note is a revealing insight into Patrick White and since it might have been lost I'm glad Brett pasted it into his painting.

After he got Brett's reply Patrick emptied his house of all Brett's paintings he had collected over the years. He sent them to the Art Gallery of New South Wales. Manoly begged him to keep the painting of the billabong, which Manoly loved, but it had to go, too. Only one work, which Patrick loved, the stones in the red dirt, was allowed to stay.

Kate Fitz Patrick White. 1980.

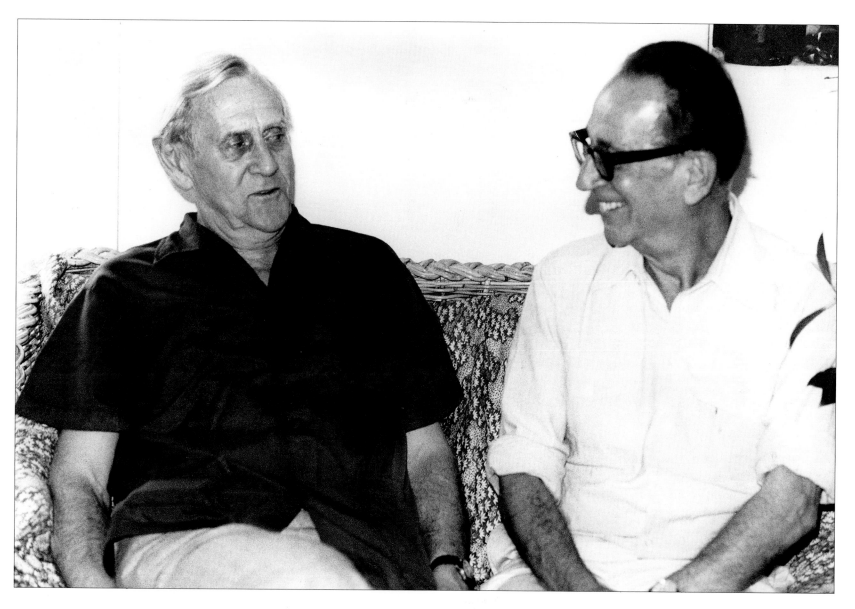

Patrick and Manoly. Kate's place, Kings Cross. 1980.

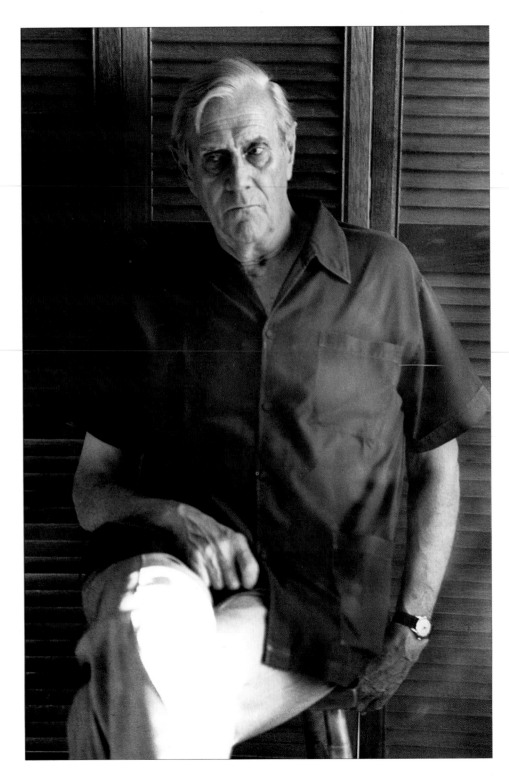

1980.

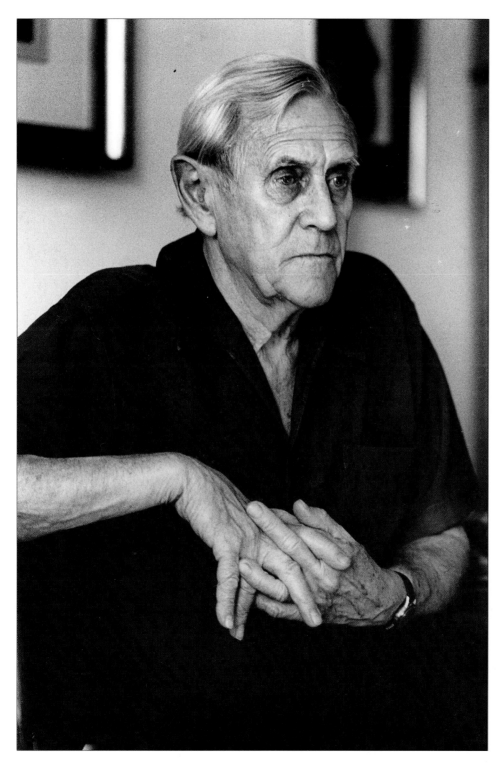

1980.

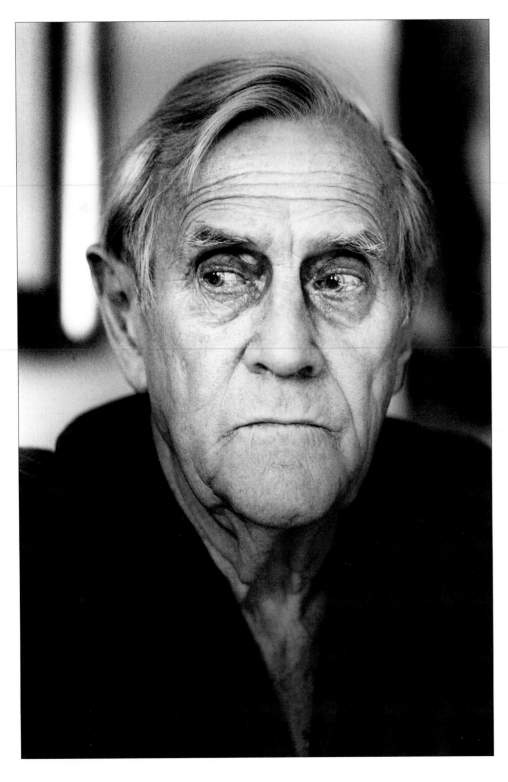

1980.

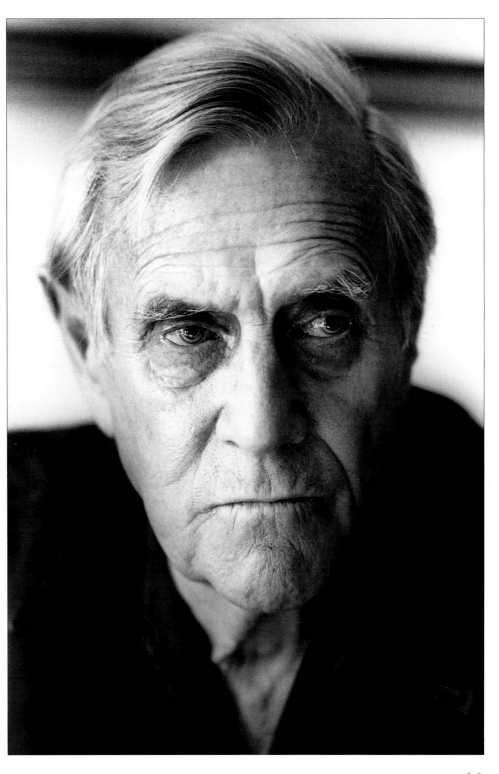

1980.

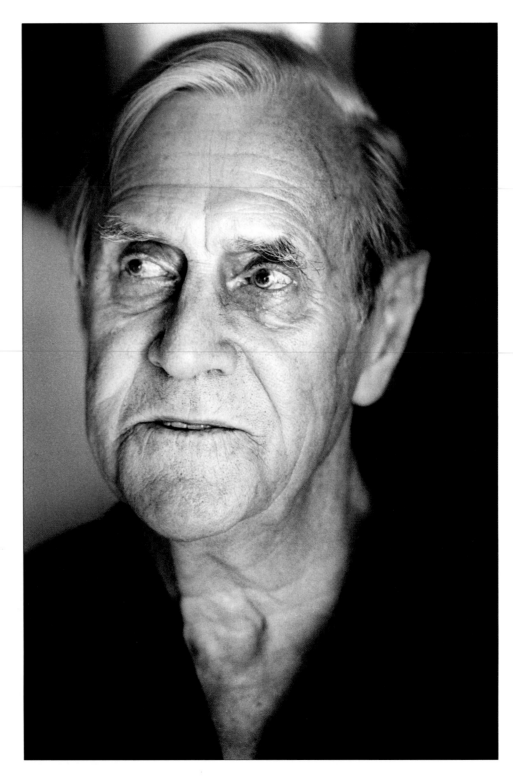

1980.

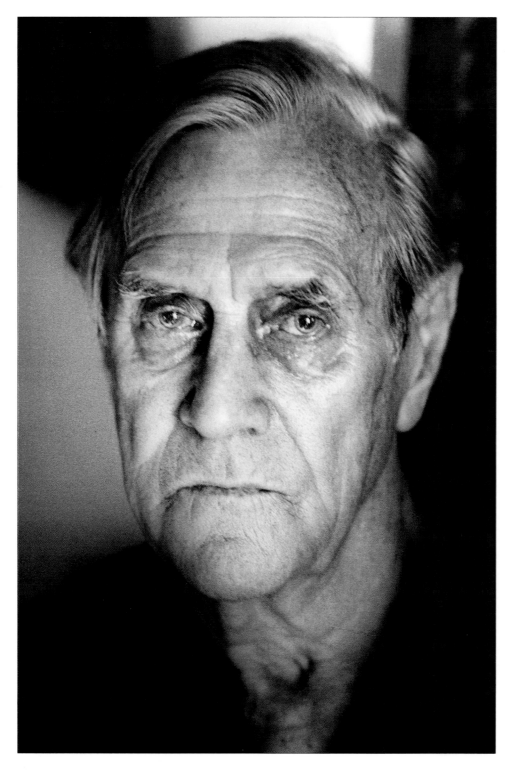

1980.

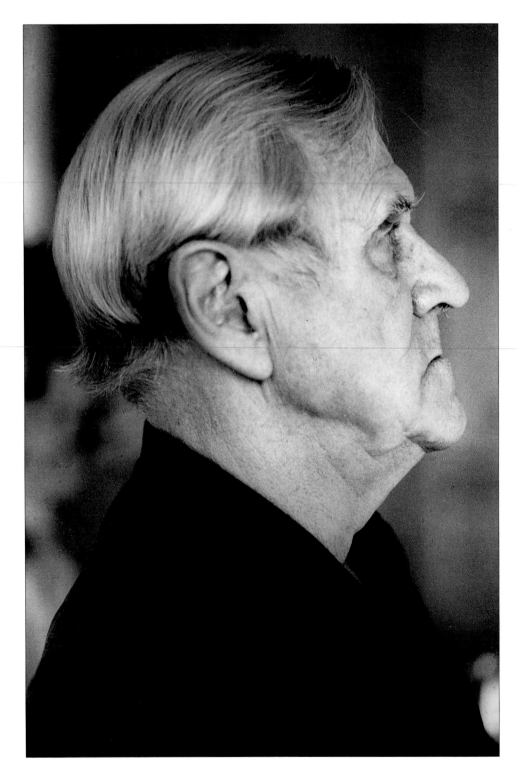

1980.

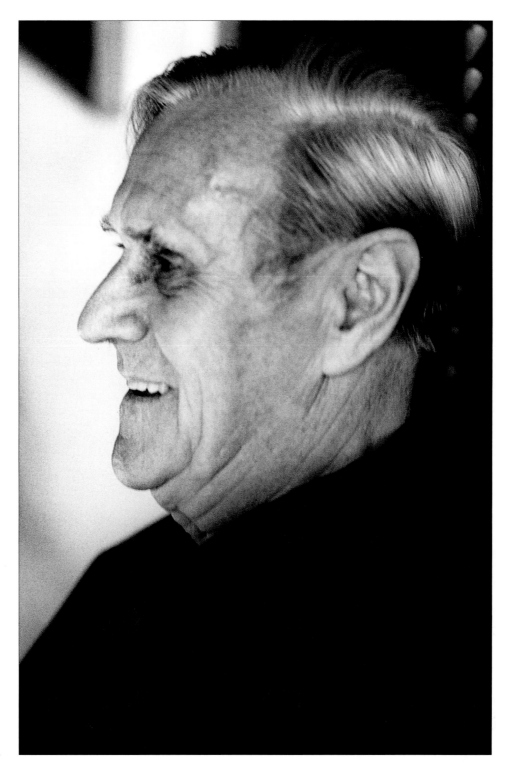

1980.

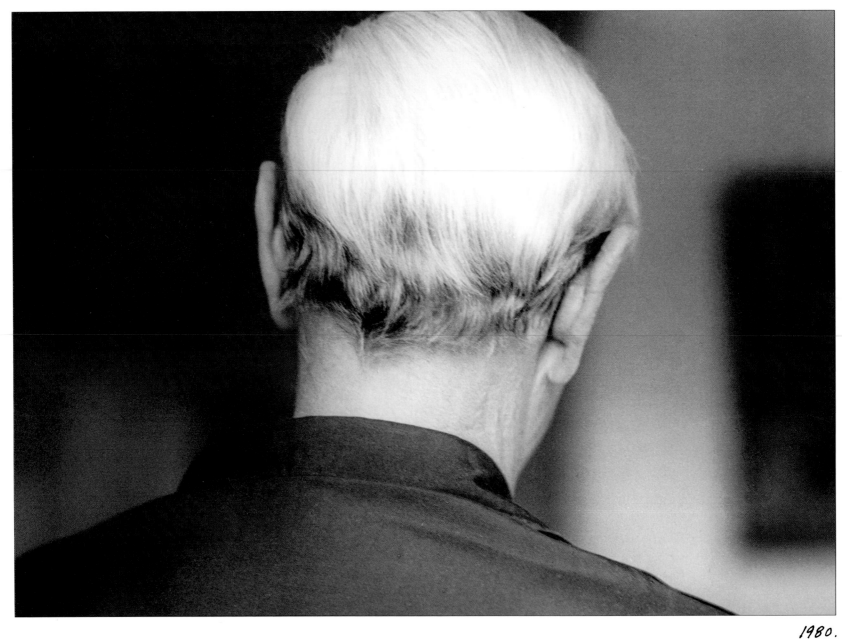

1980.

38

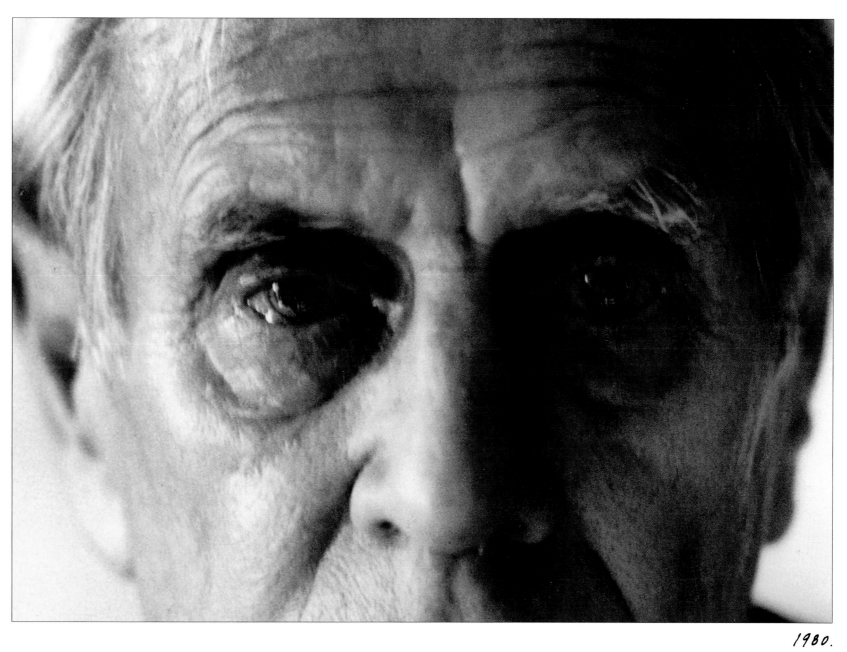

1980.

IN THE KITCHEN

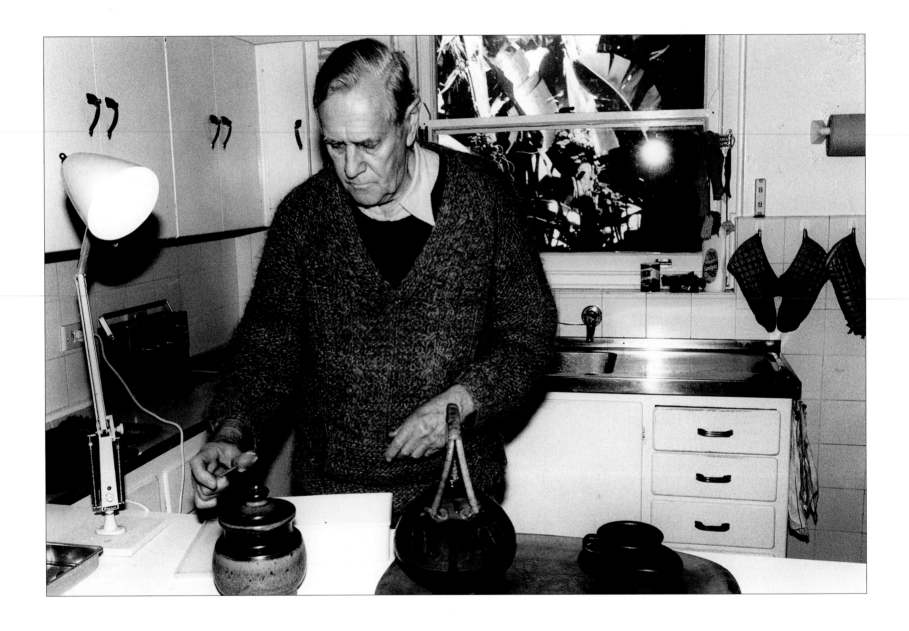

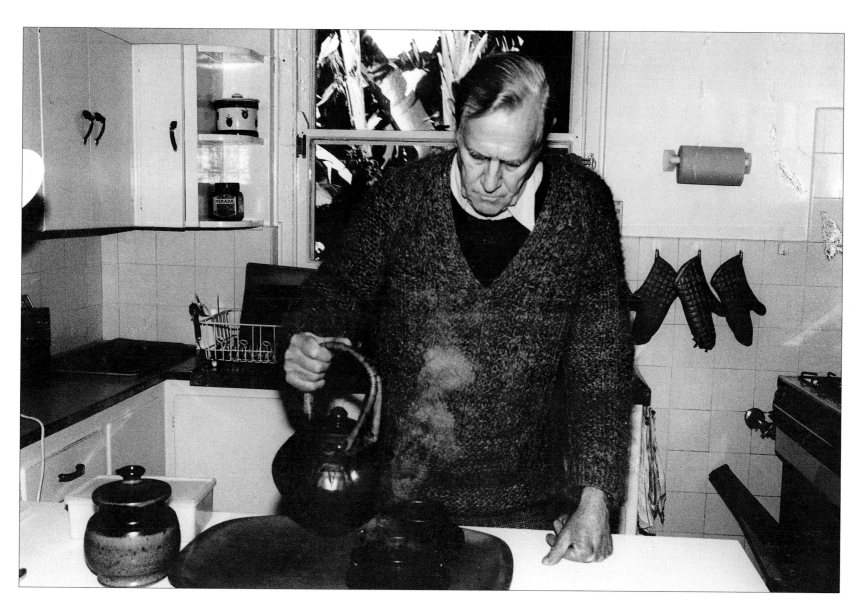

Martin Road. 1981.

ADELAIDE FESTIVAL PUBLICITY

I did the publicity photos for the 1982 Adelaide Festival which Jim directed. Jim and I called around to see Patrick just before we left to photograph the overseas artists. I took some photos of him, the best of which is on the facing page. It's one I like very much, but it wasn't so suitable for publicity.

Martin Road. 1981.

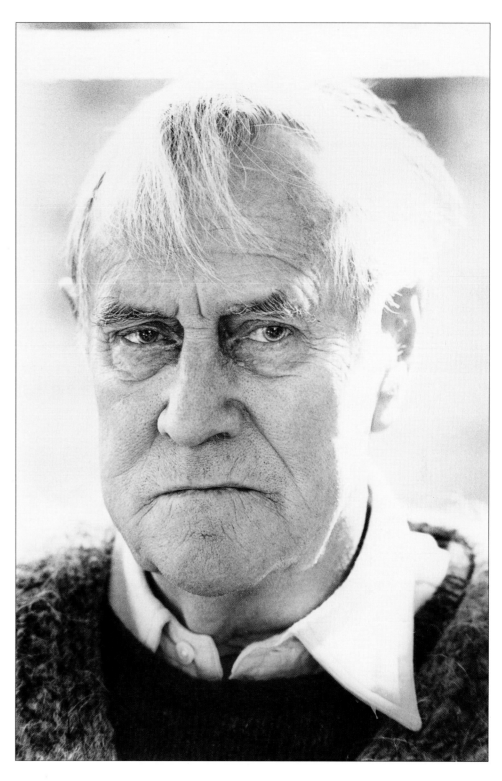

Martin Road. 1981.

THE DOGS

Manoly had an icon by a famous Greek painter, F. Contoglou. He needed a photo of it for a book that was being published in Greece so they got me over to take it. Patrick also wanted a photo of Eureka, the dog.

They liked dogs. They used to breed schnauzers when they had the farm at Castle Hill. At this stage they had two dogs: a Jack Russell, Nellie, and a large mongrel, Eureka. The latter they found under a tree waiting to die when they were walking in the park. She had been dumped, so they took her home. Previously they had had two pugs: Daisy and Pansy. Nellie was run over in 1989. She was replaced by Millie, another Jack Russell.

Patrick wrote in his list of loves and hates that he loved pugs. Only recently have I had any dealings with the breed. They are a most affectionate dog, they love human company. It's so easy to get attached to them. I thought: That's why he liked them.

He was never demonstrative with his feelings. When I took the photo, Eureka, who was large, jumped all over him, but he sat there quite impassively, hardly responding to her. I knew that he liked her, she was the only thing that he ever wanted photographed, but he found it hard to demonstrate affection. At times like this he seemed helpless.

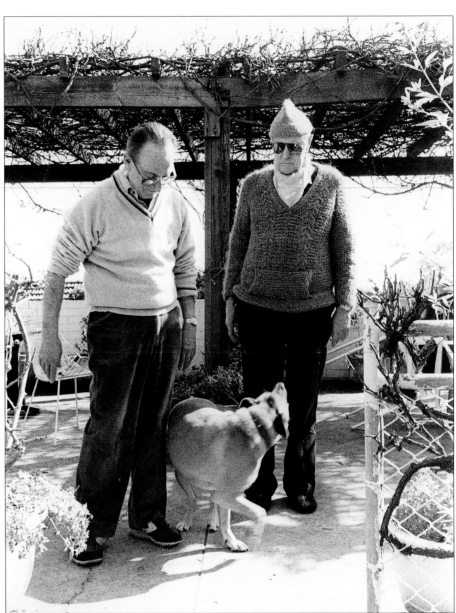

Manoly, Patrick & Eureka. Martin Road. 1982.

Nellie

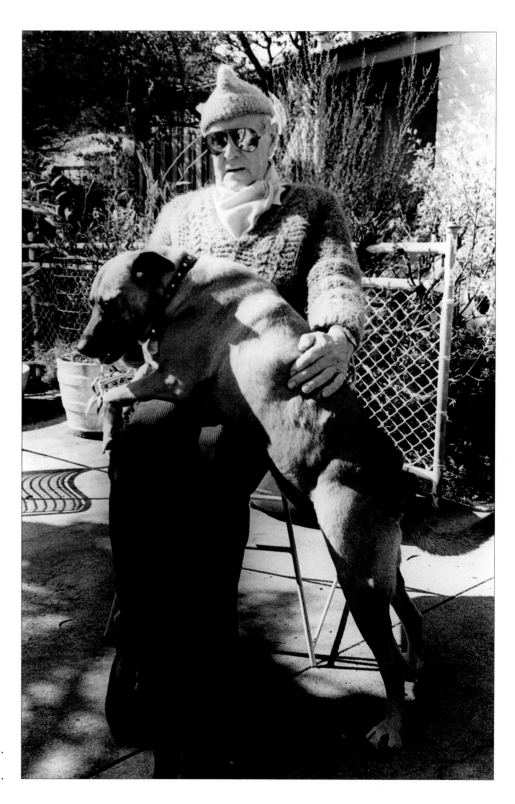

Patrick and Eureka.
Martin Road. 1982.

THE BACKYARD

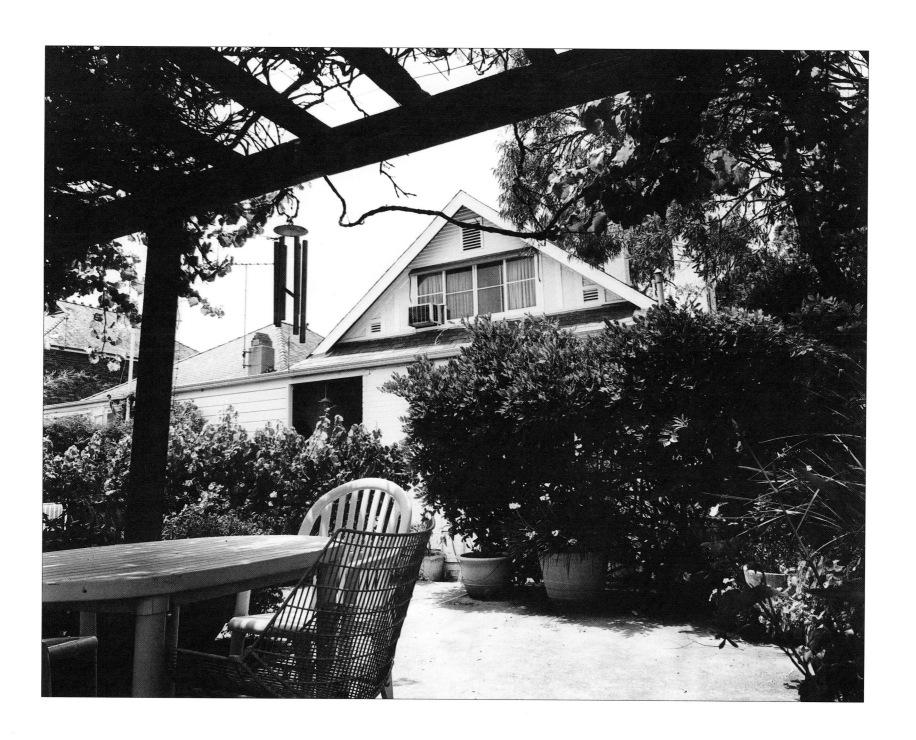

THEATRE

Patrick followed local theatre. If I rang him up we'd spend half the time talking about the plays we'd seen. It would be considered disloyal not to see one of his plays, whereas with his novels it was entirely different. I never mentioned them. Once he told me about a woman who came up to him in a theatre foyer and did a dreadful thing: she started talking about his books.

Jim Sharman commissioned *Signal Driver*, Patrick's next play after *Big Toys*, while he was director of Lighthouse in Adelaide. Jim got Neil Armfield to direct it. It was the first play of Patrick's that Neil directed. The production coincided with the Adelaide Festival which Jim directed in 1982.

After the performance Patrick got onstage and gave a speech. He stood next to the actors Melissa Jaffe and John Woods who played the roles of Ivy and Theo, and Kerry Walker and Peter Cummins who played the roles as the avatars, the vaudevillian commentators of the scene, invisible to Ivy and Theo. In each of the three acts, either Ivy or Theo comes down to the bus stop, running away from the other. They are shown in three stages of their lives: just married, middle age after the kids have grown up, and old age. Each time they manage to avert the crisis. In Act Three at the end of their lives, when their bodies have collapsed and there is no physical pride left, they find a heart in each other which is simple and true and on which they can build a permanent bond.

A few years later this play was presented at the Belvoir Street Theatre in Sydney, again directed by Neil Armfield. This time Kerry Walker and John Gaden played the roles of Ivy and Theo, and Richard Healy and Valentina Leukewicz the parts of the avatars. Patrick liked this production a little more than the one in Adelaide: it was simpler.

In 1983 in Adelaide, Lighthouse did a production of the next new play by Patrick White, *Netherwood*, directed by Jim. In the play Netherwood was an old house in the country which was used as a loony bin. One of the characters, Mog, a slightly simple girl who had killed her own baby, was written for Kerry Walker. The play is about the incipient fascism in Australian society and its intolerance to outsiders. In the end, police lay siege to the place and end up killing everyone.

Jim at first thought that one of the situations in *Netherwood* might have grown out of recent experiences in the theatre, specifically the production of *Signal Driver* in Adelaide, but the incident in question came from something that happened in the twenties. Most of Patrick's dramatic situations had some genesis in actual events, but Jim takes great pains to point out that Patrick rarely lifted a situation from life verbatim. He almost always worked it through the grinder of his imagination and transformed it into something else, so there is a great danger in making easy connections between things that happen in Patrick's work and real life events.

Netherwood was one of the two works that the Lighthouse company brought over to Sydney in 1984 for a

season at the Seymour Centre as part of the Festival of Sydney. The other was Neil Armfield's production of *Twelfth Night*.

There were parties after each of the opening nights of the two plays. I don't think Patrick White particularly liked large groups of people, but he was not antisocial, and while he had the reputation of being a grouch, I would say he definitely enjoyed himself at these parties. It was a chance for him to meet and observe people and he could dine out on the bones of gossip for weeks afterwards. Ever since the success of Jim's production of *The Season at Sarsaparilla*, Patrick had become quite outgoing. Jim said it had a rejuvenating effect on Patrick as a writer, and not only for his theatre works.

John (Tilly) Tasker was at the *Netherwood* party. John had done the first productions of *The Ham Funeral*, *The Season at Sarsaparilla* and *Night on Bald Mountain* but, after a rocky liaison, he and Patrick had fallen out. Now, twenty years later, John, on this occasion, was rather loud – on the border of being offensive – and he attempted a reconciliation with Patrick. He drew from him a cold dismissive response. Neil found John licking his wounds after this encounter and he recalled the opening night after *Night on Bald Mountain* when he received a telegram of support from a friend expressing sympathy at having to work with such a dreadful person as Patrick.

Jim Sharman, as a teenager, had seen John's productions of *The Ham Funeral* and *The Season at Sarsaparilla* and found them formative experiences of inspiration. Jim was now upset that Patrick would not acknowledge John for those early productions. At this time when many of his old plays had been successfully revived and, with new plays in production, Patrick could have afforded to be generous to John – especially since he was not in particularly good shape. He lacked generosity, Jim accused. Patrick was unmoved; forgiveness was not his strong suit.

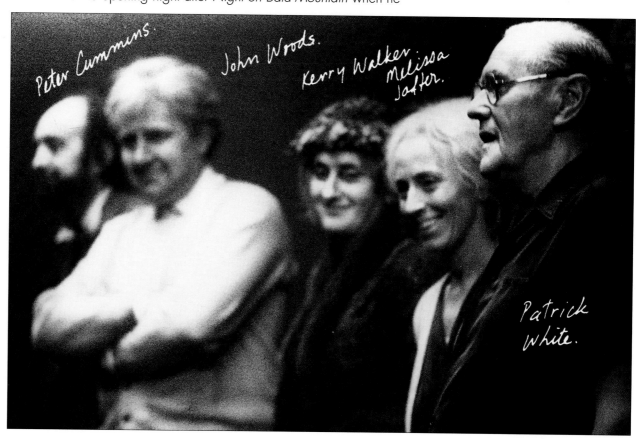

Peter Cummins. John Woods. Kerry Walker Melissa Jaffer. Patrick White.

After "Signal Driver." Adelaide 1982.

49

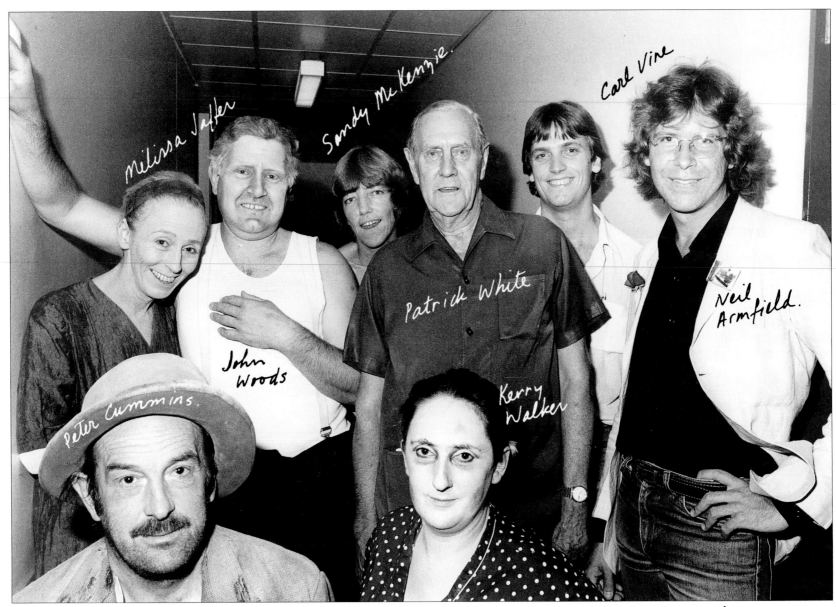

Milissa Jaffer

Sandy McKenzie.

Carl Vine

John Woods

Patrick White

Neil Armfield.

Peter Cummins.

Kerry Walker

Adelaide. 1982.

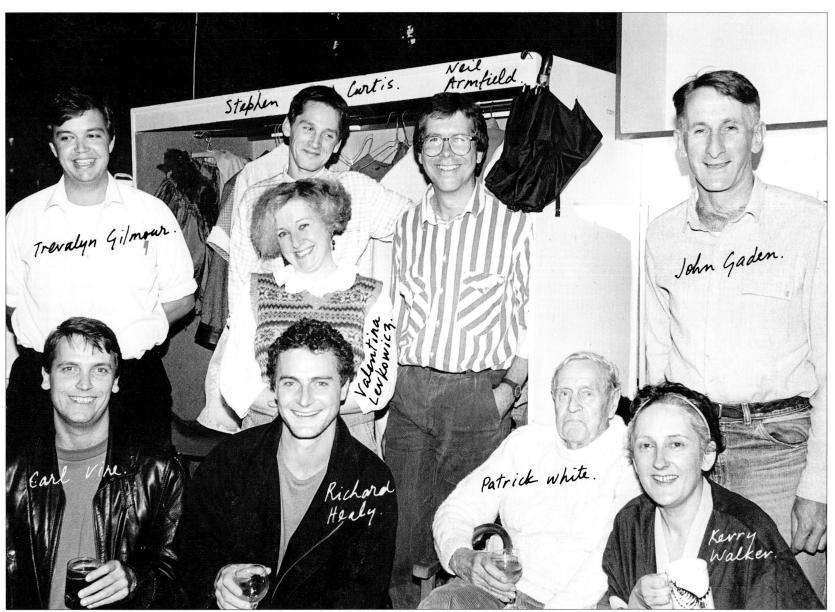

Belvoir St Theatre. 1984.

THE PARTIES AFTER TWELFTH NIGHT AND NETHERWOOD

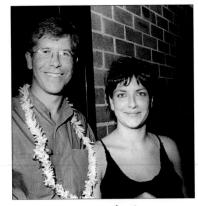

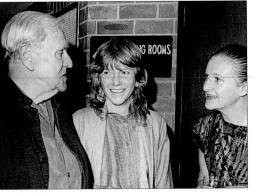

Neil Armfield
Leane Donnelley.

Simon Bourke
Melissa Jaffer

Krissy Koltai
Geoffrey Gifford.

Allan Johns Patrick White.

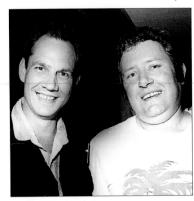
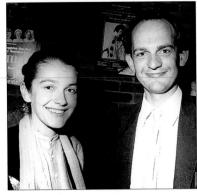

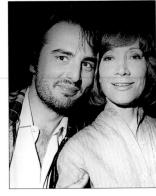

Brian Thomson
John Woods.

Melita Jurisic
Tim Game.

Patrick White , Fran Moore,
Elizabeth Knight.

Mark Gould
Jane Harders.

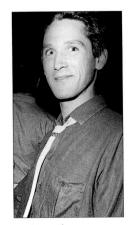
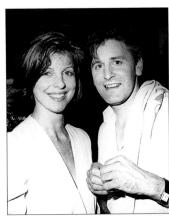

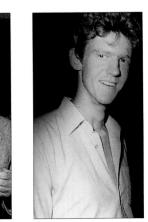

Stephen
Curtis.

Heather Mitchell
Robert Grubb.

Alison
Summers.

Robert Menzies. John Clark

Nicholas
Parsons.

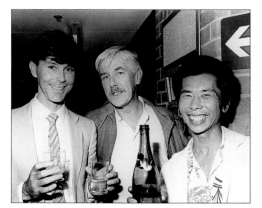
Peter Crayford, John Tasker
William Yang

Nigel
Levings.

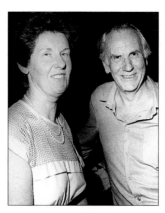
Katharine Brisbane
Philip Parsons.

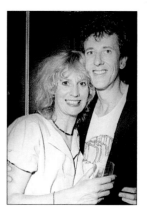
Jacqui Philips
Geoffrey Rush.

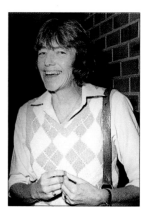
Sandy
McKenzie.

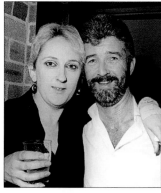
Kerry Walker,
Bill Shanahan

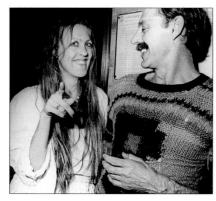
Sue Hill, Barry Otto.

"Netherwood" cake.

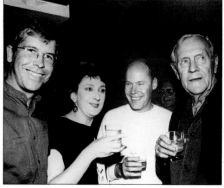
Neil Armfield, Kerry Walker,
Jim Sharman, Patrick White.

Jill Sykes.

Stephen Sewell
Aubrey Mellor.

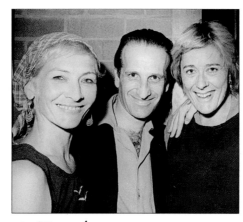
Gillian Jones, Nico
Lathouris, Margaret Cameron.

Mary
Valentine.

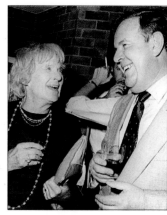
Elizabeth Riddell
Stephen Hall.

53

DEMONSTRATIONS

Patrick used to ring his friends to remind them of the Hiroshima Day demonstration, rather as a date we dare not miss. He had a thing about nuclear disarmament and you need only to read the book *Patrick White Speaks* to realise the depth of this noble passion. But nobleness is a difficult aspiration to muster on an overcast Sunday morning and it was not without mutterings that I made my way to Hyde Park that day to find I was the only one of our crowd who had bothered to show up. No one had told me it wasn't compulsory.

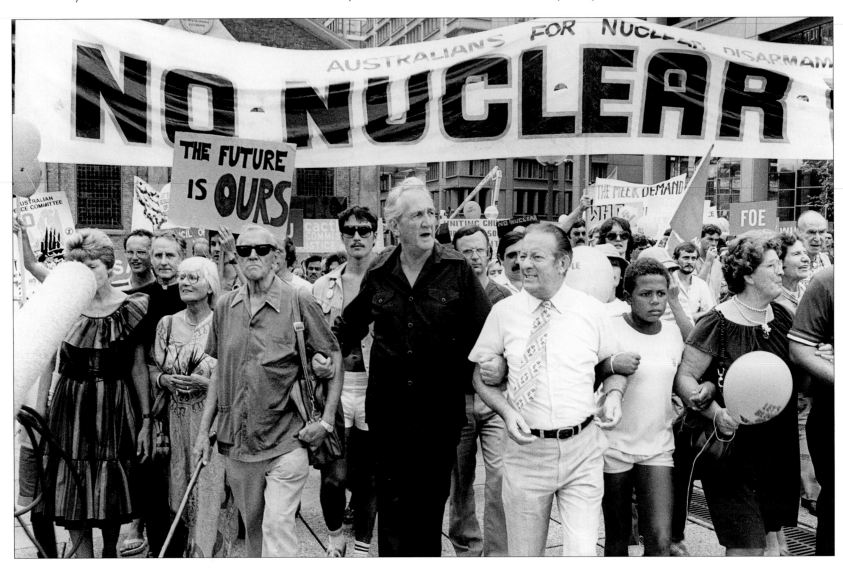

Sydney City. 1984.

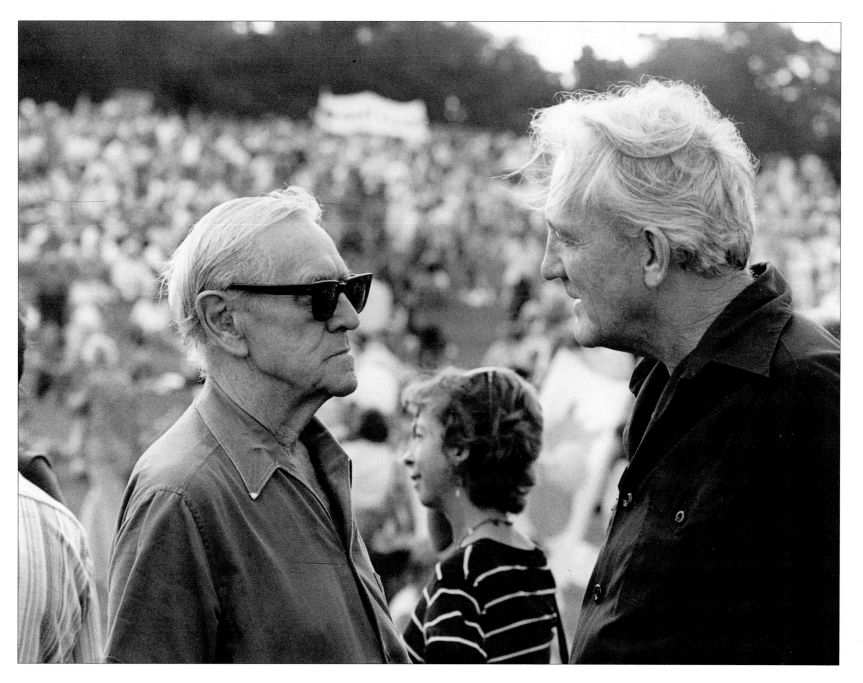

Patrick White and Tom Uren. Domain. 1984.

ON THE COUCH

This day I was quite bold. I had my camera out all the time I was there and took photos around the house the way I usually do with friends. Patrick and Manoly were sitting on the couch and I attempted a smiling photo. To get a smiling photo you often need a high degree of social interaction, because you are trying to get the subjects to laugh. I guess I bullied them into it.

As I was leaving, at the gate, I took another photo. It was the last straw. Patrick made a cutting remark. I forget what he said exactly but it was very dismissive. I was stung. I'd gone over a certain boundary and pushed him too far.

Later that day I was walking down South Dowling Street when I saw an old bag lady carrying a suitcase and several plastic bags. She struggled. I went up to help her and, as I reached out to carry her suitcase, she thought I was trying to steal it and pulled her possessions to herself. She had a thin face with a moustache and eyes that had known the harsher side of life. She snarled at me then let out this high-pitched whimpering sound like a dog.

I've always connected those two experiences. Partly because they happened one after another and partly because the old woman was like a character in Patrick's novels, if not a personal nightmare. He had a terror that he would end up that way. He knew that he had been brought up with a great deal of privilege and he was also aware of those people on the other side of society. In some ways he envied the perceptions their alienation had given them.

Once Neil Armfield took him to see a performance of *The Sand Pit* at the Performance Space. After the show they were catching a taxi and Patrick ran out onto the road to hail one down. The driver thought he was a drunk and shouted at him, 'You're not getting into my cab you filthy old bastard.' At this case of mistaken identity, Patrick was thrilled.

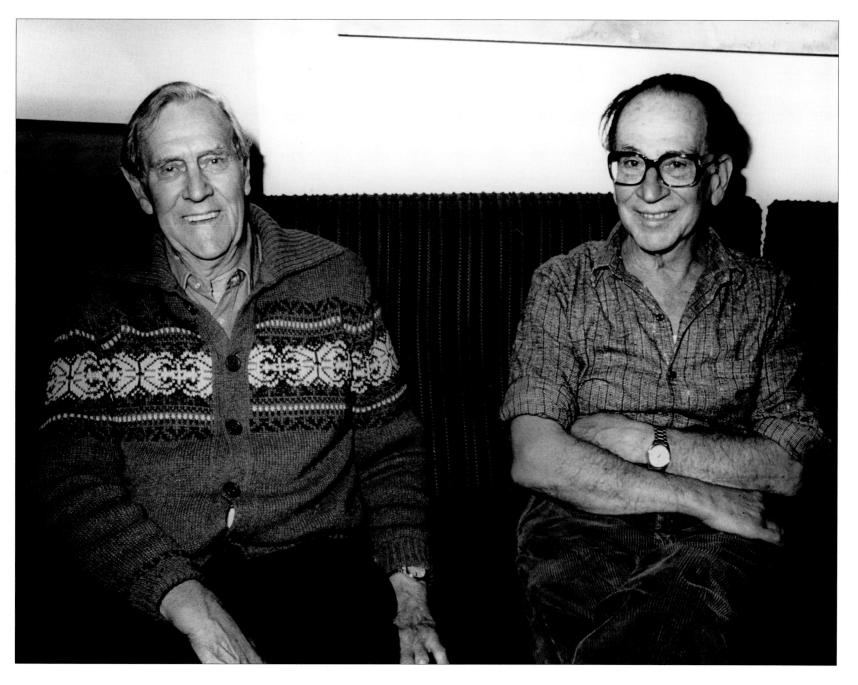

Martin Road. 1985.

THE FOLLY OF PATRICK WHITE

Patrick rang me to ask if I could take some photos of him for the jacket of his new book, *Memoirs of Many in One*. He explained that the book was about a deceased woman, Alex Xenophon Demirjian Gray, who has left a diary. Her daughter Hilda comes to Patrick White and asks if he will edit the memoir. In her time the old woman had lived in Greece and in a mental institution and had been a nun and an actress. She tended to wander in her memoir. She was a little senile. 'She is me,' he went on to explain, 'so I thought I'd have a photo of me as her on the frontispiece and a photo of me as Patrick on the back flap.'

I went over to dinner to pick up the manuscript. We ate in the kitchen. 'We don't have people in the dining room any more,' Patrick explained. 'We only have people in the kitchen.' On the way out I noticed that indeed the dining room table had not been used for a while. It was covered with pamphlets, letters (opened and unopened), and magazines. A large baked bread crocodile, dry as parchment, sat in the middle, as though waiting to munch its way through the pile of paperwork.

I read the manuscript and made an appointment to take the photos on a Monday. I wondered how I was going to take the photo of Patrick as Alex. I assumed he had some costumes tucked away somewhere, that perhaps he'd kept some clothes that belonged to his mother.

On Sunday, Manoly rang and told me that Patrick was ill and had been taken to the casualty ward at St Vincent's Hospital. The night before they had gone out to dinner at a friend's place and after the meal Patrick suffered a stomach upset and had trouble breathing.

Patrick rang me from the hospital. He didn't sound ill, he sounded quite hearty. He had an idea for the photo. In the book Alex died in hospital; Patrick as he lay in bed staring at the wall thought it would be a good backdrop for the scene. The hospital sink and the cross on the wall could remain. The TV screens could be covered with archangels. Greek icons could be added. Since Alex liked cats he imagined some cats collated into the scene.

I dropped everything and arrived at the hospital earlier than expected, while he was still eating lunch. The first thing that he told me was that the nurse had taken away his breakfast tray before he had the chance to finish.

So we chatted while he finished lunch. I got the feeling that although he did not like being ill he enjoyed being in hospital. He didn't want to be in a private ward because he'd be alone with only an intercom. The public ward had its problems. At first he had a very boring man in the bed next to him, but then there was a change and he had a lovely old man who told him how to cook squid. That day there had been a scare in the room opposite when someone's heart failed. A crowd of hospital staff gathered to give electric shocks. The person recovered and things quietened down again. When Patrick first came in he had to go to casualty and that, he told me, was like the lower depths.

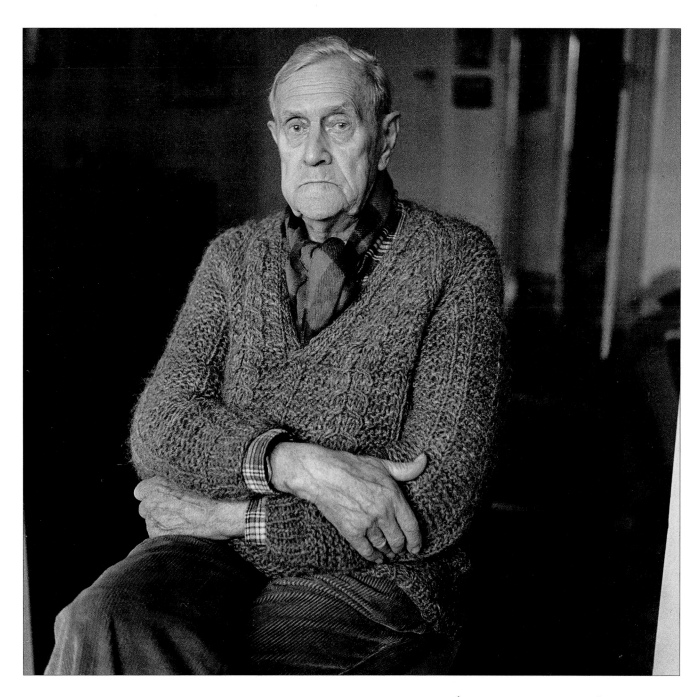

Bedroom. Martin Road. 1985.

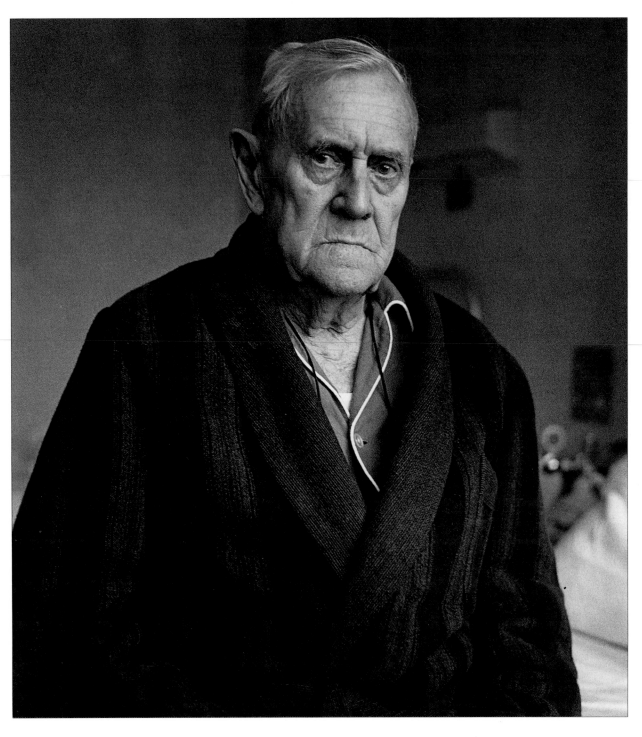

St Vincent's Hospital. 1985.

'The lower depths? Gorky's *Lower Depths*?' I asked.

'Yes. It was like a Russian dungeon,' he thundered, as if I was completely obtuse.

Before we could take the death scene we had to find the sister-in-charge to ask her if we could move the bed. We found her and I asked. He then told her that the nurse had taken away his breakfast tray before he had a chance to finish. She agreed to let us move the bed. Nurses helped. Everyone made a fuss of him. The doctor came in and said, 'Is this what happens to you when you're famous?' A wards man came in to see what was happening and I overheard Patrick telling him about his breakfast tray. Then we took the photos.

I liked the photos a great deal but they looked like Patrick White in bed and not like Alex Demirjian Gray at all.

After he returned home I explained this problem to Patrick by phone and suggested we needed a costume and a stylist. I asked him if he knew anyone who could make him up. He did not. I suggested Kate Fitzpatrick.

'No,' he said. 'She'll make me look like a tart.'

So I asked him who did Kerry Walker's make-up. He said that Jill Porter did her make-up for *The Night the Prowler* but usually she did her own. I suggested Kerry would be perfect and he agreed.

Kerry was approached. She read the manuscript in a day then a date was set to take the pictures.

It was a wet day and I arrived groaning under the weight of every camera that I owned. Kerry was already there doing Patrick's make-up. We looked at the costumes that Kerry had brought. A black kerchief tied on Patrick's head made him look Greek. We decided that for her death scene, Alex should wear a white nightdress with a lace front. I looked for a location for the hospital scene. The only two possibilities were Manoly's bed or Patrick's bed. Manoly's bed was better because it was small and the room was like a cell; it had an ascetic quality, in contrast to Patrick's room which was too vast and sensuous to be a hospital ward.

Kerry took me aside in the hall and told me that Manoly was upset because he had been told nothing of the plan. Patrick claimed that he had been told, but clearly there had been a lack of communication, and it was something of a shock for Manoly to have us traipsing in on this Saturday morning, upsetting his routine and dressing up Patrick. We asked Manoly if we could use his room, and this upset him further. In the end he agreed and he helped me move a few icons from the shrine to his bedroom.

Alex died with a trickle of blood running down the side of her mouth. Kerry produced a blood capsule and painted an artistic trickle of blood down the face. Patrick was not fussy about how this looked, although over the weeks he had mentioned it several times as a detail that appealed to him.

'I said I'd never do this after Edith Sitwell,' he said.

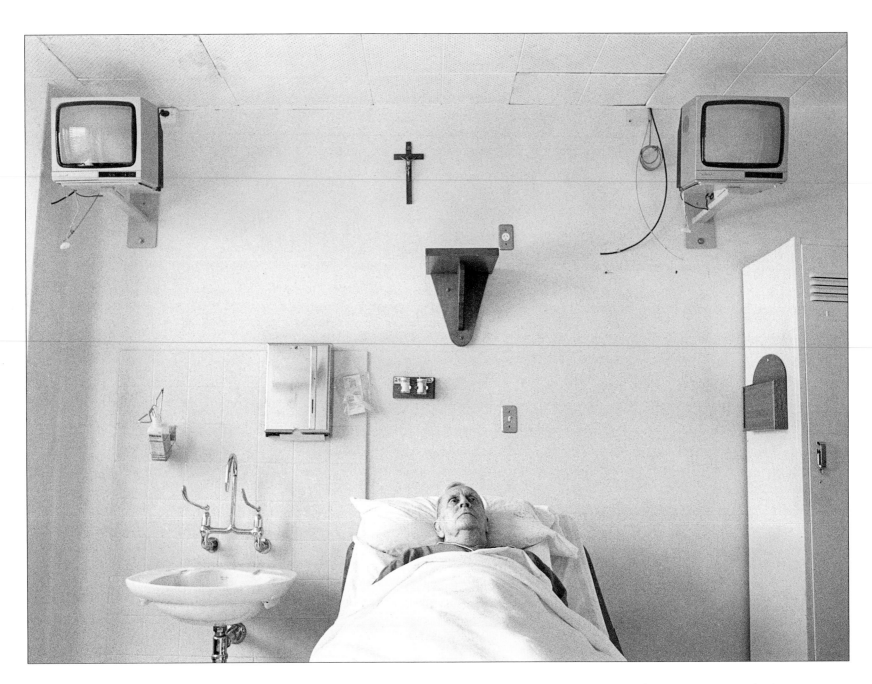

St Vincent's Hospital. 1985.

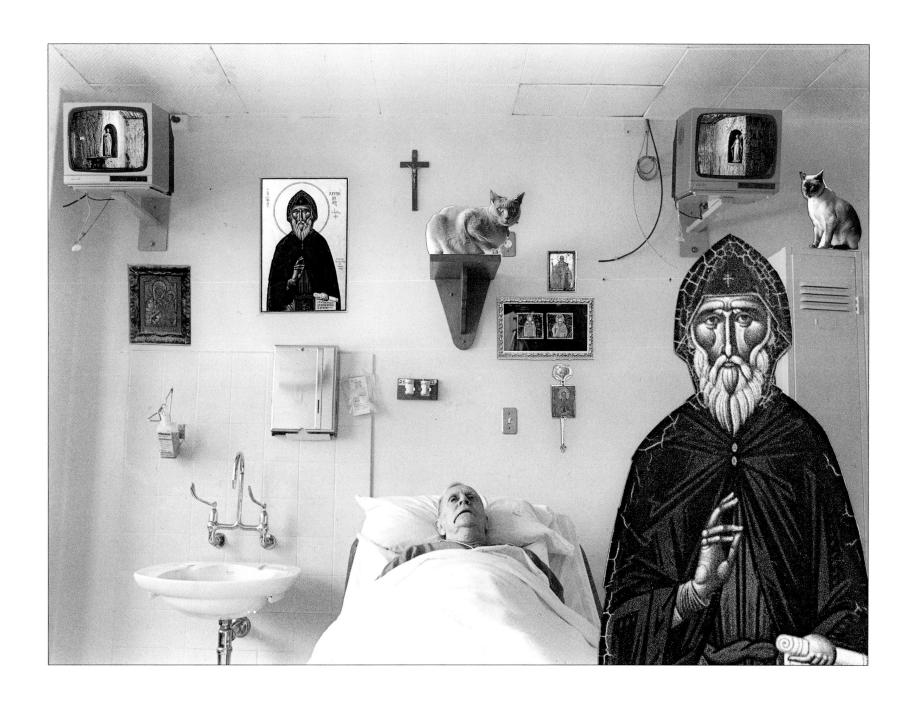

'What did she do?' I asked.

'Oh, she was always posing as a corpse.'

We took the pictures of the death scene. They didn't take long since there weren't many variations on posing as a dead body.

Kerry wiped off the blood and threw a poncho over the nightdress and we did the portraits of Alex when she was alive. I had trouble getting the right look, but halfway through I decided to take pictures in partial shadow and this was more successful.

The operation till now had taken hours so we stopped for lunch. Patrick complained that he felt uncomfortable in the costume and he was dying to get back into his own clothes. After he changed he made us lunch. Manoly, who was not theatrical, had retired to the back room and we dragged him out. Patrick was in a state of excitement and he forgot how to make the mayonnaise. For him this photo session was like being on the stage. Over lunch he and Kerry had a fight or, rather, they reconstructed a fight they had already had. They had been to see a show of Robyn Archer's the night before, and Patrick, who hated it, had announced loudly from the third row that it was boring. Kerry had sided with the actors and had taken exception to this remark.

'You don't say it there. You wait till you get outside, and then you can say what you think,' she said.

'That's so Australian just to sit there. It was boring,' he maintained. 'Overseas, the audience boos poor performances.'

'You don't shout it out in the middle of a performance out of respect for the actors,' she insisted.

'You're only saying that, Kerro, because you're an actress.' The argument ebbed and flowed throughout the lunch.

There was no afternoon nap for Patrick. We got straight into taking pictures of him as Patrick White for the jacket. We worked through the session at a moderate pace. Then Kerry grabbed the dog Nellie and tried to get her to bite Patrick, so I took some photos of that.

I left feeling quite pleased with the way things had gone and I thought that Patrick had enjoyed it, too.

I showed him the proofs. He didn't like any of the death scene. He thought the blood was too theatrical and the kerchief was askew in some photos. He liked the photos of Alex in partial shadow and he liked the wall of icons. We decided to collage a detail of Alex onto a shot of the icons. Surprisingly he liked the photos of himself as Patrick. We chose some.

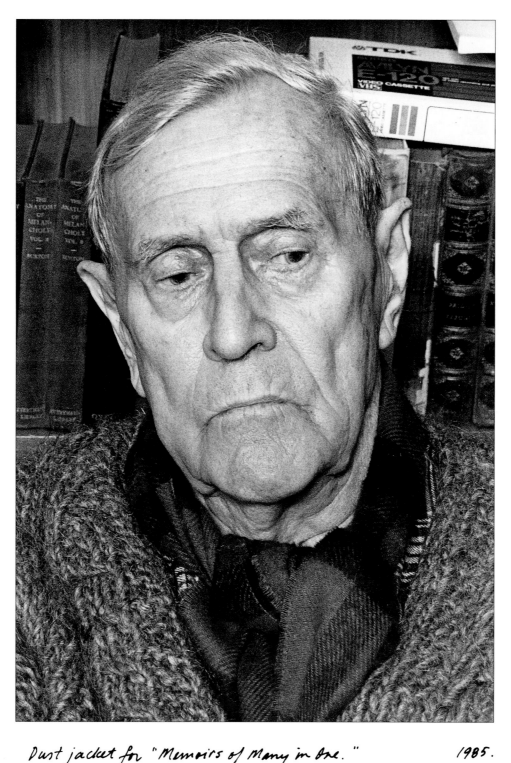

Dust jacket for "Memoirs of Many in One." 1985.

'This one,' he said.

'No,' I said, 'too fierce. What about this one?'

'No,' he said, 'too much doubt.'

I delivered the prints the next day. They had become urgent and had to be sent to Jonathan Cape, the publisher, in London. They had come out well, especially the superimposition of Alex. He held up the picture, looked at it for a long time and pronounced a verdict: 'Yes, she looks Greek, she could have been a nun, she could have been an actress and she could be a bitch.'

We had some lunch. We were always eating. This time it was a rice concoction with fish. He apologised, 'It's only leftovers – we're already had it twice. I can't bear to have leftovers for a third time but Manoly makes such a fuss if I throw anything out.'

After lunch Patrick proudly showed Manoly the photos. Manoly viewed them coolly. 'You've captured a certain feminine side of Patrick,' he said to me, but to Patrick he said, 'It makes you look like Toula Kouros.'

Patrick screamed in fury: 'When you say something like that, it makes me want to tear up the picture.' This was, no doubt, the effect Manoly intended. Like Alice B. Toklas with Gertrude Stein, Manoly knew exactly where to place the knife.

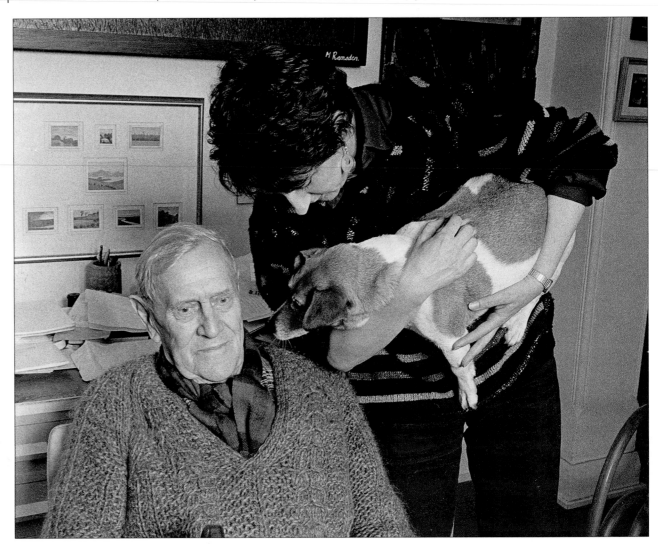

Kerry getting Nellie to "Bite him!"　　　　　*Martin Rd. 1985.*

We got down to business. Patrick wanted two photos of Kerry trying to get Nellie to bite him, one for Kerry and one for Manoly. He would pay me for those and the publishers would pay me for the others. He gave me the number of his agent, Barbara Mobbs. He wrote out the address on a card. His handwriting was firm, direct and absolutely confident.

I rang Barbara Mobbs. We discussed my fee and she agreed to arrange payment. She was, however, being strangely off-hand during this conversation so I asked her how she liked the photos.

'Well, I've been thinking. It's probably not a good idea to use the one in drag. When I first saw it, I thought it was a hoot, that it was terribly funny, but when I came home and thought about it I decided he'd be leaving himself wide open. The photo will be reproduced and sensationalised by the newspapers. I can just imagine the journalists going on about that lacy nightdress. He has a lot of enemies. He has been very critical of these people – quite rightly so, I believe – and they are ready to come back and have a go at him.'

Next Patrick rang me. 'I've decided not to use the photo in the frontispiece. They've all advised me against it. Manoly hates it. It turns out no one liked the idea in the first place. Jim now tells me he always thought it was a terrible idea. I couldn't give a stuff about it. But I'm sorry they talked me out of it. I suppose I will have to write to Cape and tell them I've changed my mind. Cape will pay you for the photo of me on the jacket and I will pay you for the other one.'

'So we'll regard the whole thing as a folly,' I said.

'A folly I'm paying for. Still, I don't suppose they will be lost. You can bring them out some time . . . when I'm ashes,' he chuckled.

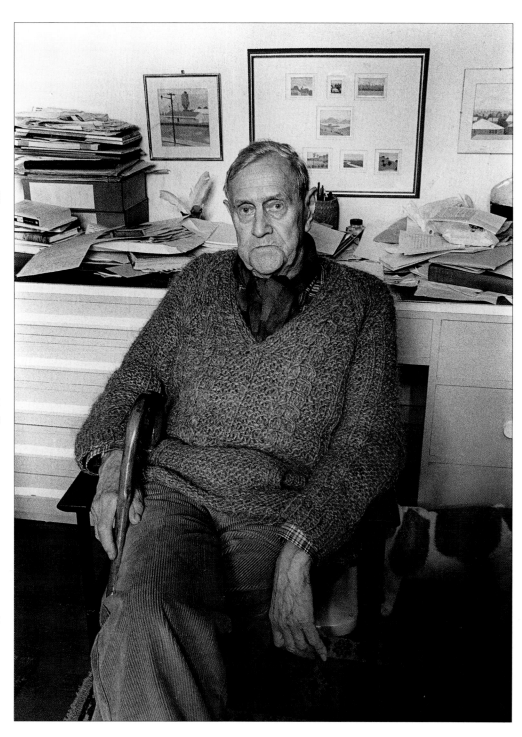

In front of his desk. *Study. Martin Rd. 1985.*

THE BEDROOM

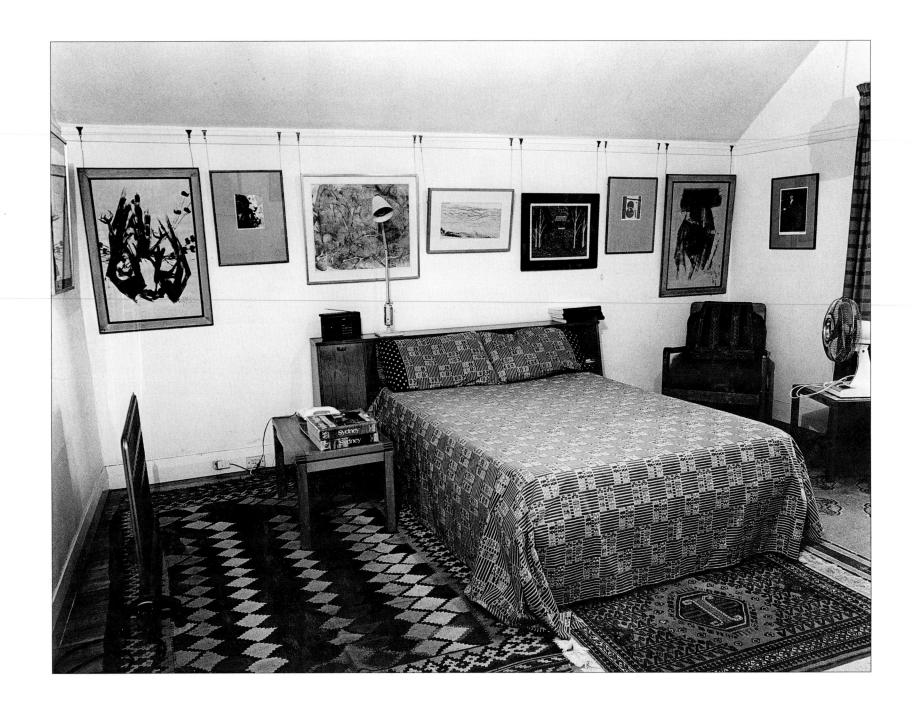

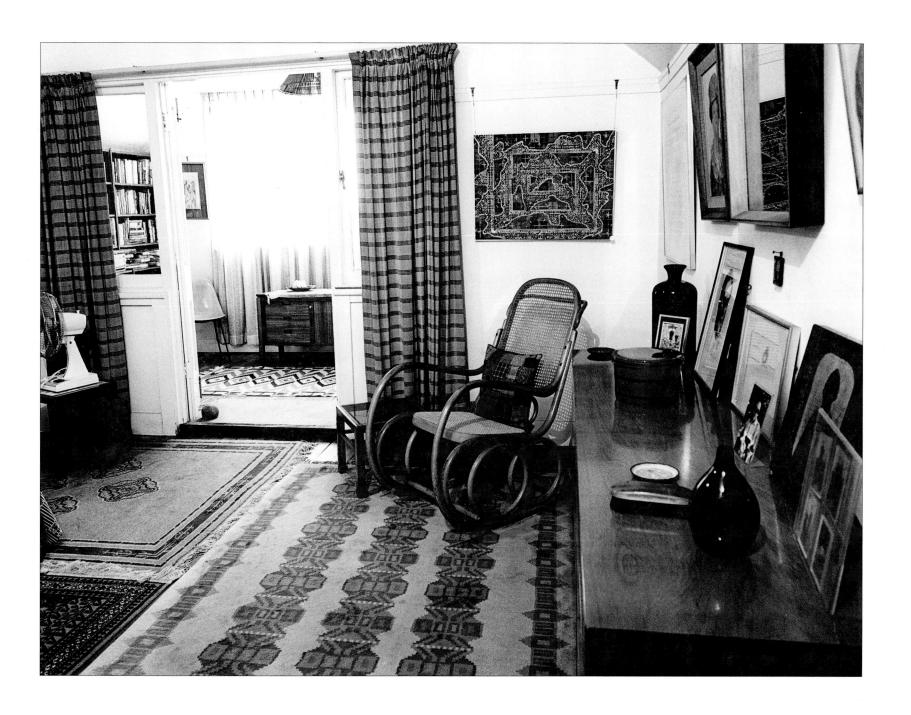

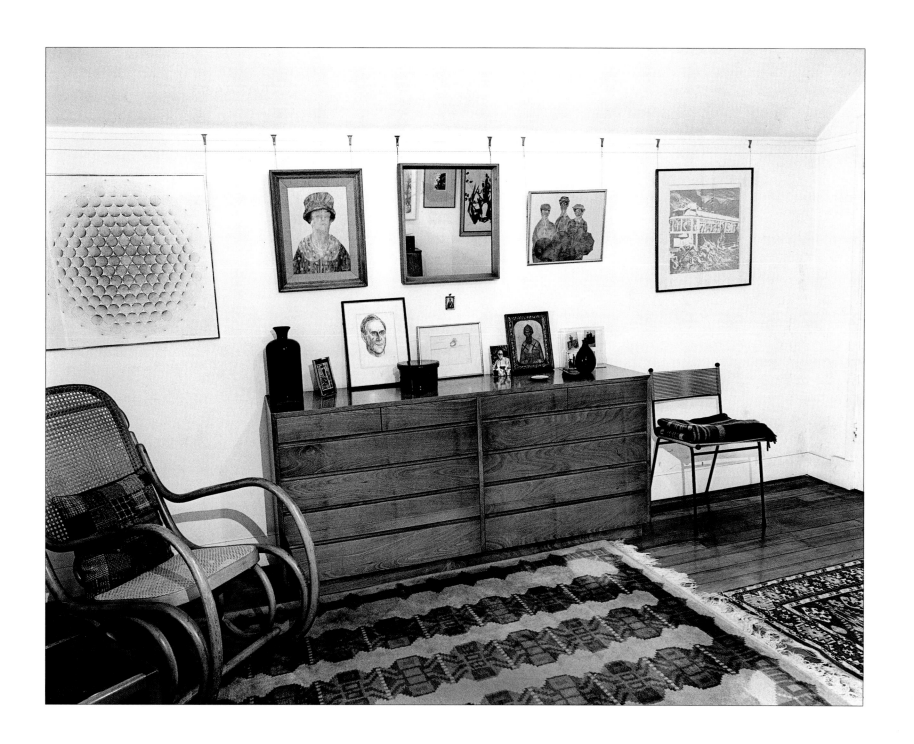

POSTSCRIPT TO FOLLY

I showed Patrick my piece, 'The Folly of Patrick White', after I wrote it and he liked it, but he said it was full of mistakes. I asked him what they were. I had got two of his titles wrong. *The Night the Prowler* I had written as *The Night of the Prowler* and *Memoirs of Many in One* I had written as *Memoirs of One in Many*, and I had confused the daughter Hilda with the husband Hilary. However I committed my worst mistake when I described his table top, reporting that there was a copy of *Meanjin* there. 'Meanjin!', he thundered, 'That's Leonie Kramer's magazine. I wouldn't have a copy of that in my house.' He calmed down. 'That seems to be most of the more glaring errors,' he concluded.

The piece was published in a book of mine entitled *Starting Again*. I made the mistake of not immediately sending him a copy because I only had one. He heard from another that there was a photo of him on the back page. That was bad enough but the fact that he heard about it first from another made it worse.

The photo was quite small but he was angry. He expected his friends to keep his friendship as a thing of private value. He judged and was reassured by friendships that were between only him and the friend, and had nothing to do with anything else. He hated the idea that someone would use his name for their own self-promotion.

On the phone I explained to him that I was upset about the photo on the back page because the publishers hadn't told me about it and I agreed it was inappropriate. He told me there were new attacks on his work and now his enemies were claiming that all his female characters were drag queens. He asked me if the photo of him in drag was in the book. I assured him that it wasn't and that I had, in fact, already shown him all the text and all the photos that were used. He said something like, 'I suppose you're going to bring the photo out some time.' I had no intention of bringing it out. In fact, I think that after reading the story of Alex Demirjian Gray the photo is a complete anticlimax; the image works better if it exists in people's imagination. There is also something in me that is protective of my photos. I don't like promising never to use a photo because twenty years on the situation may be completely different. On principle I wouldn't promise Patrick never to use it. He was silent for a moment and he said in a disappointed tone, 'You just can't trust anyone.'

I left it a few months and then I rang him again and he was quite pleasant. We never mentioned this incident again.

THREE POTATOES AND TWO GUEST STARS

This photo was not set up, the potatoes were there. He really liked those potatoes. He put the photo in the frontispiece of his book of short stories, *Three Uneasy Pieces*, titling it: 'Three potatoes and two guest stars.'

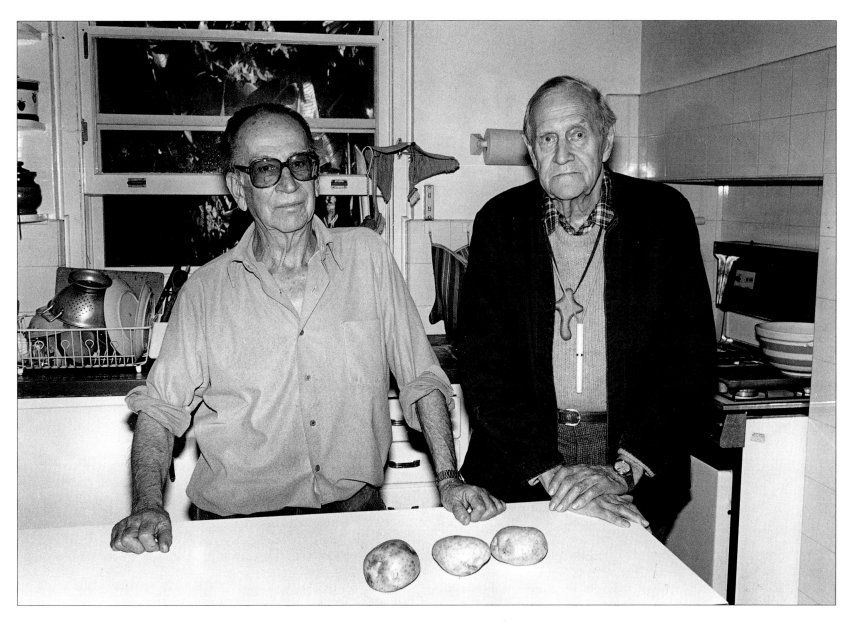

Kitchen, Martin Road. 1987.

PORTRAITS

There was an unwritten rule. He would not give interviews and he would not allow his photo to be taken unless it was for the promotion of his plays. He would relent on these occasions because of the actors. To get an audience for them, he would cooperate with the PR machine which he hated. He did it for them.

In 1987 I did a photographic series on writers and I asked him if I could take his picture. He thought that the idea of writers as a photographic subject was terrible: too much time was already given to the cult of the writer, the papers were full of it and festivals had a whole week of writers which was a waste of time. However I continued in my persuasion and he agreed.

When I was taking the photos he recalled, 'I'll never forget the first time you took my photo, you said: "What a dreadful mouth you've got." '

I didn't remember it like that at all; certainly I would not have had the courage to say that to him. I remembered taking his picture, noting that his mouth was a problem, and the next time I took his picture I said, 'I've got to be careful of your mouth.' I told him my version.

He insisted, 'No you said: "What a dreadful mouth you've got."'And he laughed. He had a misanthropic view of himself and that was one of the keys to his sense of humour. At times it could get blown up to theatrical proportions – he declared to David Marr, his biographer, 'I'm the greatest monster of all times.' The *Herald*, of course, picked up on this statement and ran it on the cover of their weekend magazine; but I thought it was printed out of context, and shouldn't have been taken so seriously.

He was quite old at this stage and suffered from osteoporosis which is a crumbling of the bones. He used to drink milk for the calcium. As I made him sit in different positions in the living room, I was aware that he was in some discomfort. After quite a short while he said he'd had enough and I had to talk him into doing one more shot in front of the dining room table which was covered in letters and paper paraphernalia and was one of my favourite images in the house.

Later when he was making me a cup of tea he said accusingly, 'You didn't photograph me in the kitchen. It's where I spend half my time.'

I was stunned. What a lost opportunity! 'Why didn't you ask me to?' I replied.

He said, 'I couldn't bear the thought of you bringing all your umbrellas [the lights] in here.'

The photographic umbrellas appealed to him. Later he gave me a book by Richard Long for my birthday and wrote on the inside page: 'To the umbrella man'. But by then I had forgotten the session and it took me weeks to work out the connection.

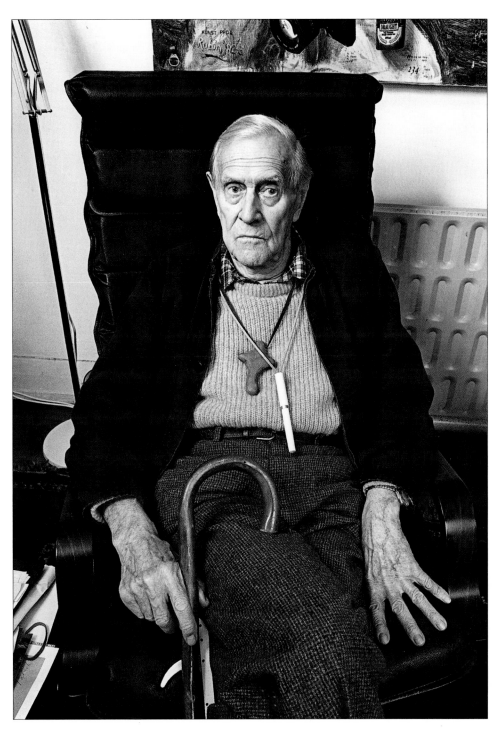

Living Room, Martin Road. 1988.

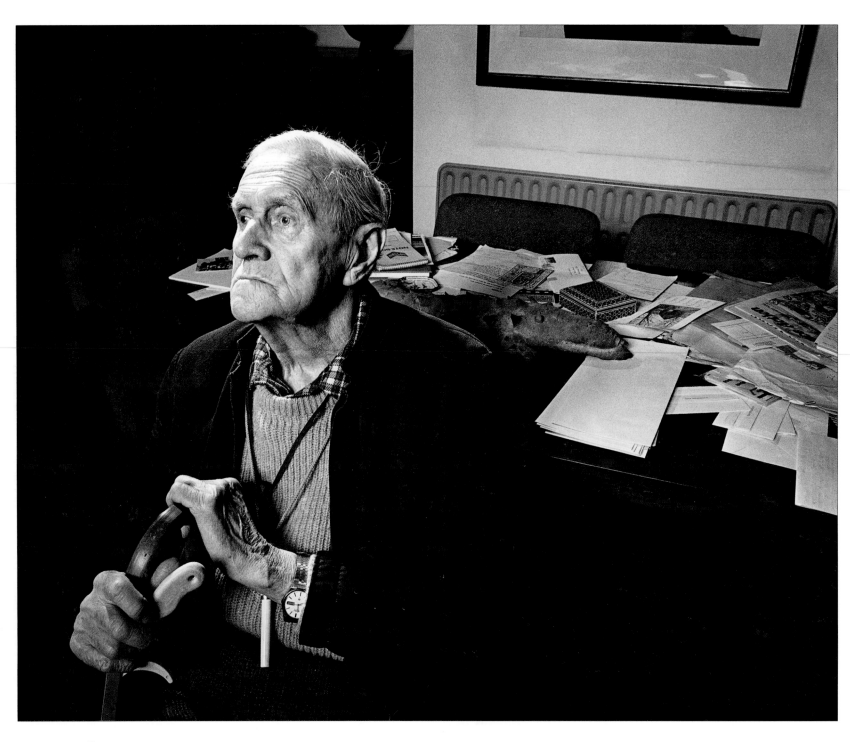

Dining Room, Martin Rd. 1988.

76

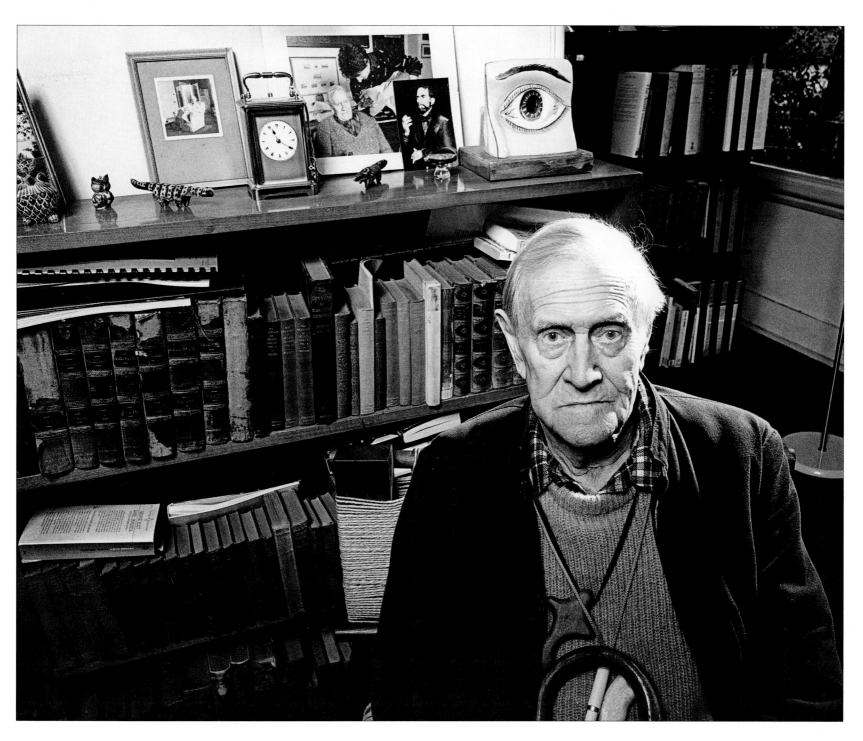

Living Room, Martin Road. 1988.

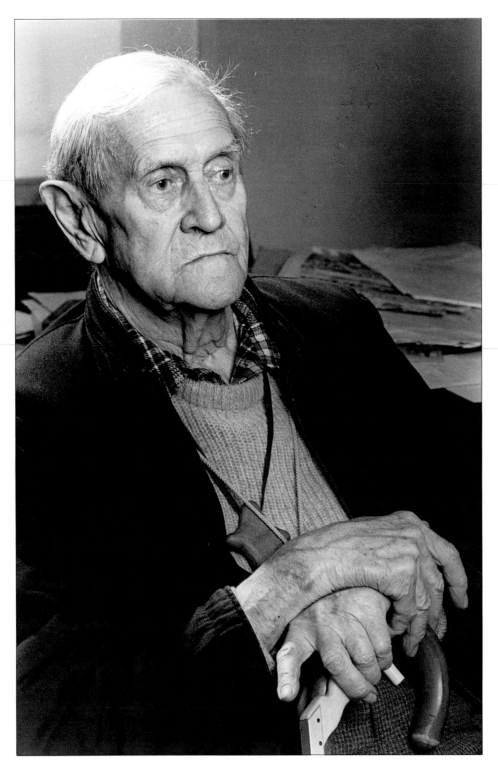

1988

78

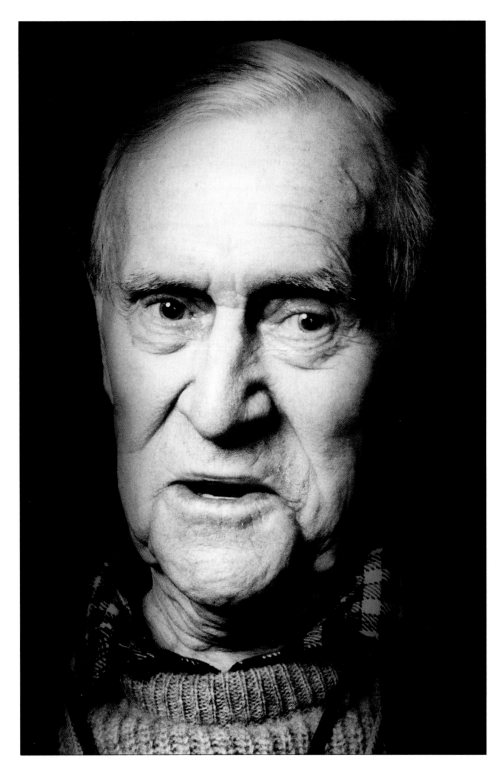

1988.

THE HAM FUNERAL

While it was John Tasker who did Patrick's plays in the sixties and Jim Sharman in the seventies, it was Neil Armfield who did them in the eighties. Jim and Patrick did not fall out like the previous partnership: their working relationship came to an end with Jim wanting to move on to do other things and Patrick looking for someone new to produce his work.

Neil said he started off doing *The Ham Funeral* without a great deal of confidence. He knew that while a lot of the play would work, some of it he feared would not. However he found, as he did with the other plays, that when he persisted and found the technical form, the difficult parts did work and became quite beautiful.

The Ham Funeral is about a young man, an artist, who comes to live in a 'great, damp, crumbling, old boarding house' owned by a drunken landlord and his wife, Alma Lusty. He fantasises about the girl who lives in another room, turning her into an idealised part of his anima – she is tender, sensual, loving and aware. The landlord dies. At the funeral, the wife tries to seduce the young man. The play is based on an actual incident told to Patrick by William Dobell.

Neil describes the play as Oedipal vaudeville. The male artist outgrows the shell of his upbringing. Led on by a dialogue in his head with his female self, he ends up in a sexual wrestle with his mother. It is resolved by the artist coming to understand and feel compassion for the situation. This allows him to leave the house and move into the starry sky of the artistic universe beyond.

The Ham Funeral was the first play that Patrick wrote. So this production at the Sydney Theatre Company completed a circle: the last production while he was alive of a play about his experiences as a young man, somewhere in London, finding out he had the ability to write.

I drove him to that first rehearsal where the publicist had also arranged a photo call with the cast. It was a wet day. Patrick was waiting by his window and was angry with me for being late. Despite this, he had high hopes for the play. He said that he had been listening to the radio the previous week and had heard a voice about which he had thought: That is the voice of the anima. During the credits for the program he found out the voice belonged to Pamela Rabe, the actor Neil had already cast in the part. Many of the old gang had been recruited to appear: Kerry Walker for Mrs Lusty, Max Cullen for the landlord, and Robyn Nevin and Maggie Kirkpatrick for the two old vaudevillian women. Patrick had chosen the actor Tyler Coppin to play the part of the young man.

I dropped him off at the entrance of the theatre and watched him walk in. He had a stick and was bent over, weighted by his overcoat and a bag; he was frail and it looked as if the squally wind might blow him away, yet he walked into the theatre with a singular determination.

Richard Wherrett, the director of the Sydney Theatre Company, gave a short speech at the beginning to welcome

everyone to the theatre. Neil, of course, was the director of the play but Richard ran the company. Patrick had something against Richard or the STC – it may have been he felt the STC had neglected his plays, but he had so many things against so many people that one lost track of the reasons. During this talk, Patrick rummaged in his bag for his eye drops; a performance not unlike the vaudevillian old hags in the play and one that completely upstaged Richard's talk.

I was away in China when the play opened, but I heard it went well. Someone showed me a video of him appearing on television that night. A friend from the STC told me that on the night of the opening Patrick had ordered a cake from Sweet Art which featured the Dobell painting. In his after-play speech, Patrick praised the cast, the director and all his people but made a point of not mentioning Richard Wherrett, the STC, or their backup production team. This had hurt Richard and at one point he was in his office in tears. Tears of rage, that is, because the next week he wrote a scathing letter to Patrick that would have matched one of his.

I had invited Patrick to the launch of my book *Starting Again* which occurred at the same time and he wrote back to me. I noted that his handwriting, which had always been so firm and strong, had become a bit wavery.

Dear William,

Glad your trip to China seems to be a happy one. You know I don't go to launches, but I look forward to reading your book and hope to give some for Christmas.

The Ham Funeral has gone like a house on fire. Everyone is raving, and it is now difficult to get in. (You surely will be found a seat.) I have been maddened by some of the critics who dismiss Tyler for lacking attack. 'Attack' is just what he must not have. He is a diffident young man. They would understand better, if they listened to the prologue, which they don't appear to have done, or if they did they forget what it tells them later on. Tyler is everything I could have wished for the part.

Love

Patrick.

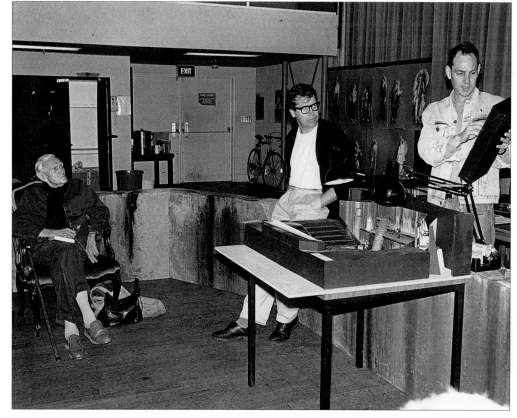

Patrick White, Neil Armfild, Brian Thomson. The Wharf. 1989.

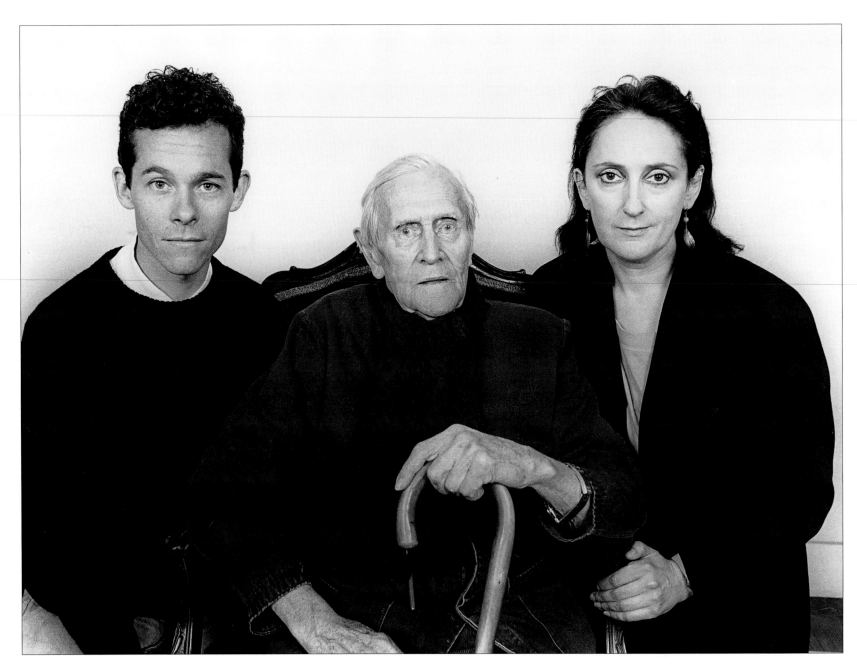

Tyler Coppin, Patrick White, Kerry Walker. 1989.

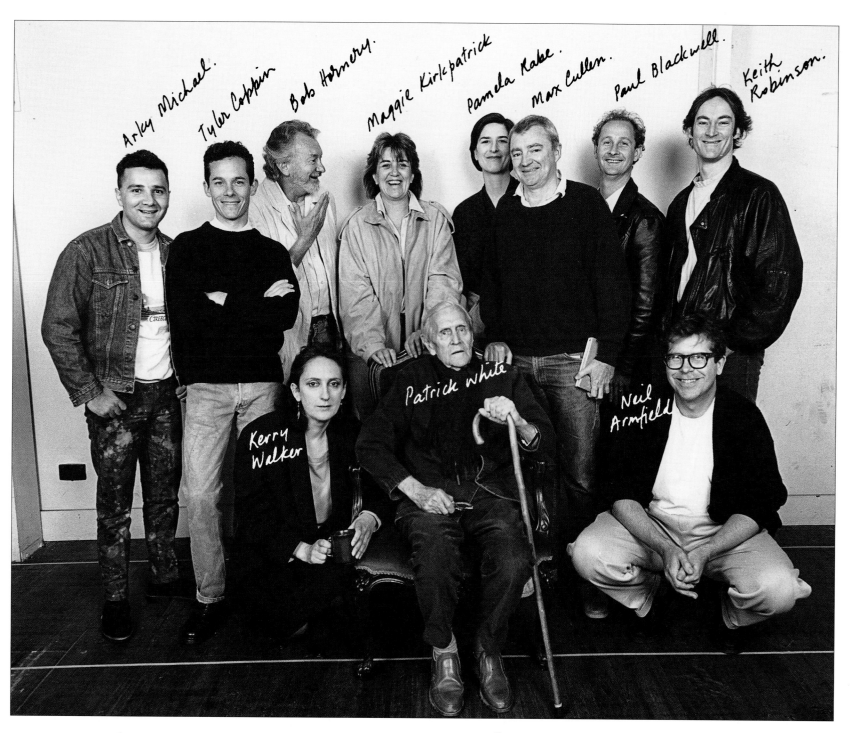

Arky Michael. Tyler Coppin. Bob Hornery. Maggie Kirkpatrick. Pamela Rabe. Max Cullen. Paul Blackwell. Keith Robinson.

Kerry Walker. Patrick White. Neil Armfield.

Publicity photo for "The Ham Funeral," commissioned by S.T.C. 1989.

MARGARET FINK'S LUNCH

Margaret Fink had just bought the rights to do a miniseries of Patrick's novel *The Tree of Man* so she asked him and Manoly around for lunch. She was not *au fait* with whom Patrick was seeing at the time so she asked Neil Armfield, who was going to direct the series, to do the guestlist. The guests, besides those people already mentioned, were Neil's parents Len and Nita Armfield, Chris Westwood, Kerry Walker, Bill Harding, Geoffrey Rush and me.

Margaret takes her lunches and dinners very seriously; she puts a lot of work into each one. She regarded this one as special and she perceived her guest of honour was a fusspot so she was determined that it would all be perfect. She had picked up the vital key to the lunch from a throwaway line from Elizabeth Riddell, who should have been at the lunch but was somehow overlooked: Patrick had said that the worst day in his life was when he lost his teeth. The key to the lunch was soft food.

That morning Margaret got up at 5 a.m. to go to the fish markets to buy a magnificent salmon which she broiled in her fish kettle. The menu she chose was curried pea and lettuce soup, followed by the salmon garnished with two branches of bay leaves and served with proper mayonnaise made by her own hand. Peeled tomatoes with roasted red capsicum, a green salad of six different leaves and a potato salad were also served. She made the potato salad twice as the first attempt was not quite right. With her second she used the slightly yellow-fleshed Tasmanian pink eyes and they were more successful. For dessert she brought a rich chocolate opera cake, which she intended to serve with fresh raspberries, from the Paris Cake Shop in Bondi Road, the best bakery in Sydney.

Margaret was not part of Patrick's circle of friends although he knew her her well enough to write to tell her he had not liked her movie *My Brilliant Career*, something she did not appreciate. He did somewhat redeem himself by writing to say he liked her next movie *For Love Alone*. Patrick had not approved of Neil directing Margaret's miniseries *Edens Lost* because he thought that Neil was getting involved in a side of Sydney that would be corrupting in some way.

Patrick and Margaret had met at various functions and at one she admired a pair of brilliant purple socks he wore. They were socks that cardinals wore, he explained, and he sent her a pair in the mail not long after. Patrick was hugely excited by the prospect of going to Margaret's for lunch. By then he did not go out much and his only worry was that he would not be well enough to go.

He was very frail; he'd shrunk to half his size. I remembered once he was about the same height as Neil, now he only came to his shoulder. When he arrived at Margaret's he couldn't sit in the deep armchairs because of his bones so there was a mild flurry while a chair with a straight back was found.

The soup was a success. Patrick drank it from the bowl without using the spoon, and that was regarded as a

good thing because he at least felt relaxed enough in the environment to be at home. The salmon was also a triumph as were the accessories to the main course, although the only drink he requested, a glass of Guinness, was not in the house. He did not, however, deduct points because of this. He did not eat the chocolate cake either, that would have been excessive, but he ate some raspberries. He watched with disapproval as the older Armfields, who had just been talking about their ailments, ate their serving of cake and then had a cup of coffee. Patrick had tea.

The dappled sun came into the dining room on that warm winter's day and Margaret, who had completely put the first potato salad out of her mind, was starting to breathe more easily now that the lunch had gone without a serious hitch. Then Patrick went to the toilet and there he thought for a moment that she had made a serious error and that he at last had something on her: there was no toilet paper. But no, he turned around and disappointedly he saw there was a spare roll on the shelf.

Margaret summed up the event: 'He may have had withered gums but he certainly could still enjoy his tucker.'

His compliment to her: 'You're a much more brilliant woman than I had originally thought,' was slightly backhanded, but a compliment nonetheless.

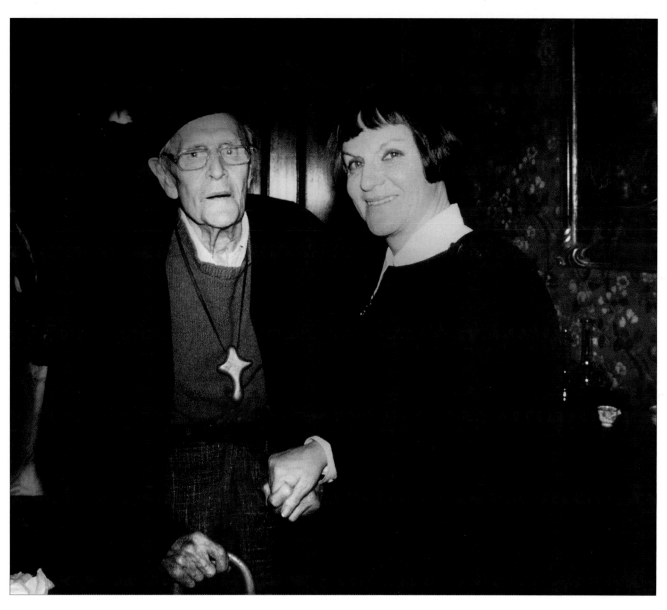

Patrick White and Margaret Fink. Woollahra. 1990.

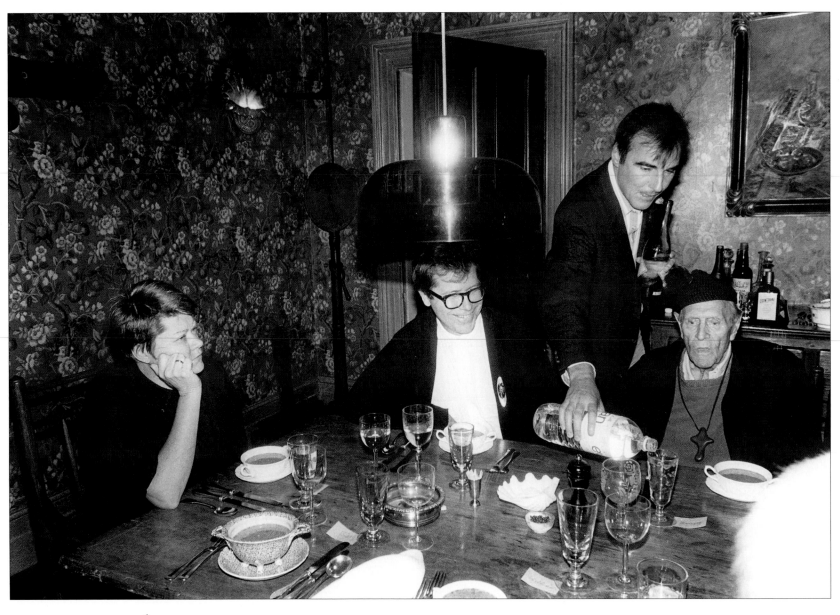

Chris Westward. *Neil Armfield.* *Bill Harding. Patrick White.*

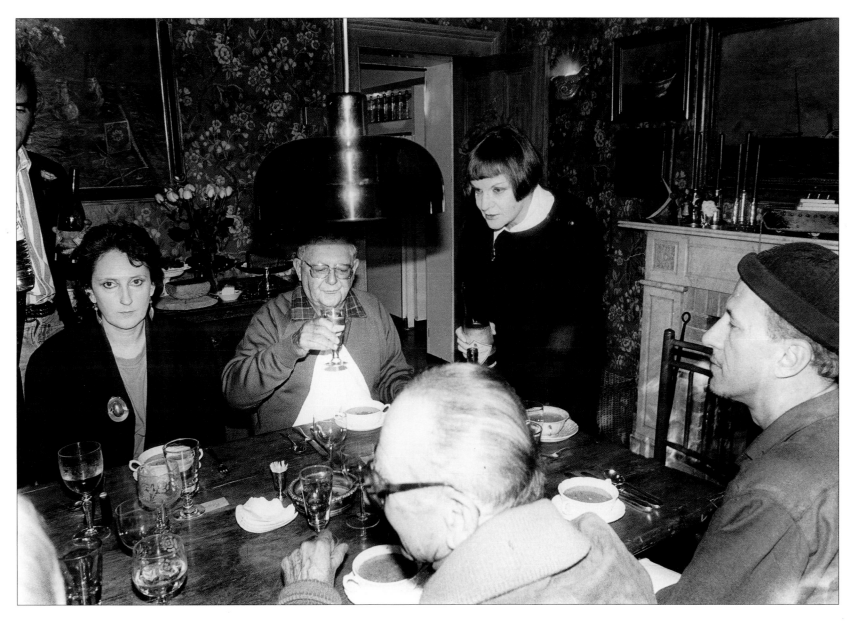

Kerry Walker Len Armfield Margaret Fink
Manoly Lascaris Geoffrey Rush.
Woollahra. 1990.

IN THE GARDEN

Neil thought of Patrick as an artistic and spiritual father, one who regarded our particular circle as his children. Patrick was someone who always had his eye on the bigger picture and with this final judgement in mind he was always scrupulous about how he thought the artist or the person should behave. Although he raged about certain attitudes in society, in many ways he looked for the goodness in people, that which was simple and unpretentious, that which was true. What he hated was hypocrisy and hype which took the form of self-promotion. He dismissed people for their actions, he had no sympathy for human failings, he was still totally uncompromising even to the end, and that aspect in him was always a bit scary. But he did get mellow in time, though that fierceness was just below the surface and his eyes never lost their defiance.

This particular day we sat in the garden. He wore a woollen beanie with a pom pom and struggled with the teapot which seemed too large. Manoly always did the garden which now was flowering and I admired it, 'The garden looks beautiful.' Patrick pointed out some of the more exotic shrubs. He knew the botanic names of all the plants. Manoly told me that he brought the cutting for the grapevine, which formed a canopy over the table, from Castle Hill when they moved. I mentioned I had seen Patrick walking in the park with a green switch. Yes, they used switches like that all the time in Egypt where there were many flies. These were usually made of horse hair and had ivory handles. He had asked friends who travelled in that part of the world to get him one but so far there were no results from his requests. So Manoly had made Patrick one from a piece of bamboo and some bright green raffia string he had bought at the hardware store. Patrick used it all the time although he had never thanked Manoly for making it.

Manoly had to take the dogs for a walk. They started to run around in excitement. 'They prefer Manoly,' Patrick said, softly. It didn't seem to mean, the dogs prefer Manoly because he's a much nicer person than me, rather, we all love Manoly, the dogs too.

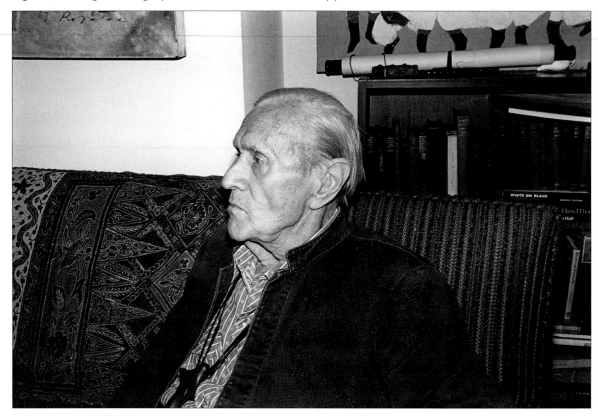

Living Room, Martin Road. 1989.

88

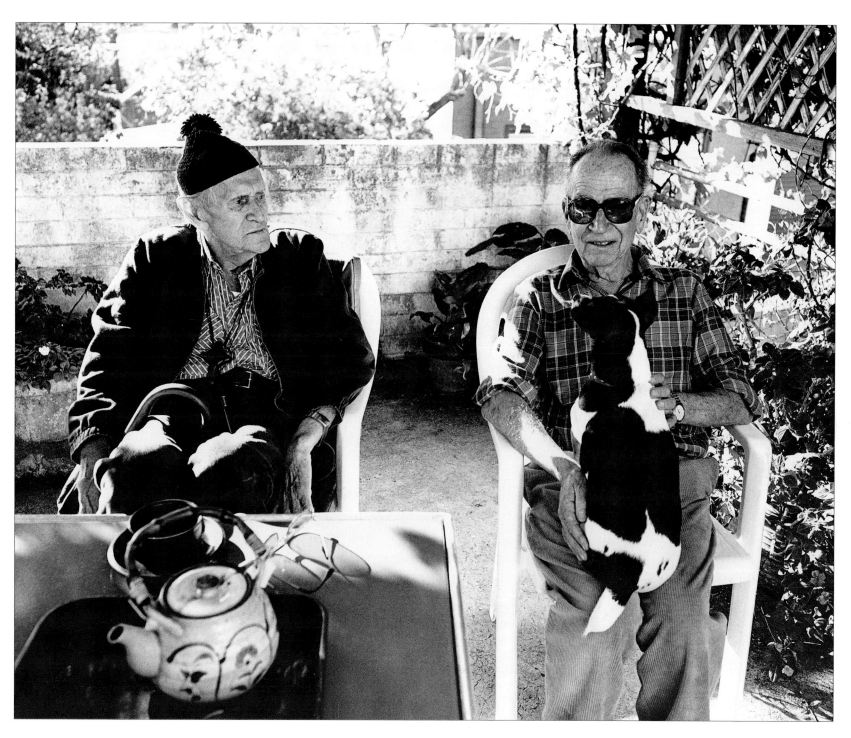

Backyard, Martin Road. 1989.

1989.

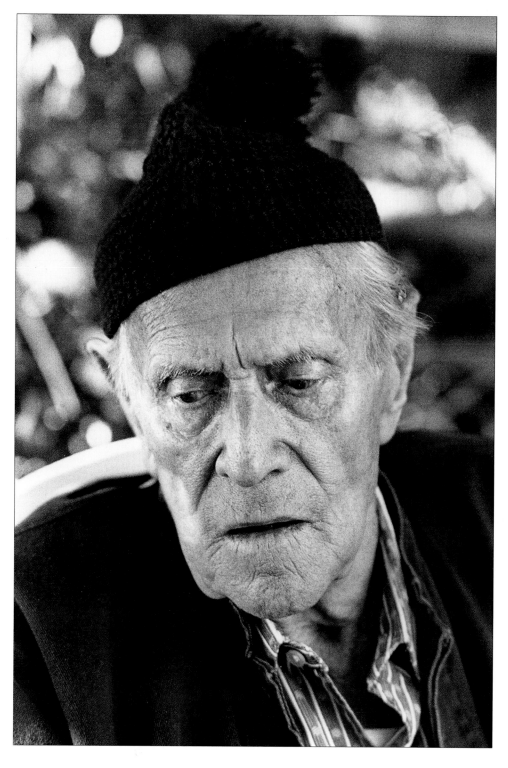

1989.

Patrick White, author and stirrer, dies at 78

Sydney Morning Herald, 1 October 1990

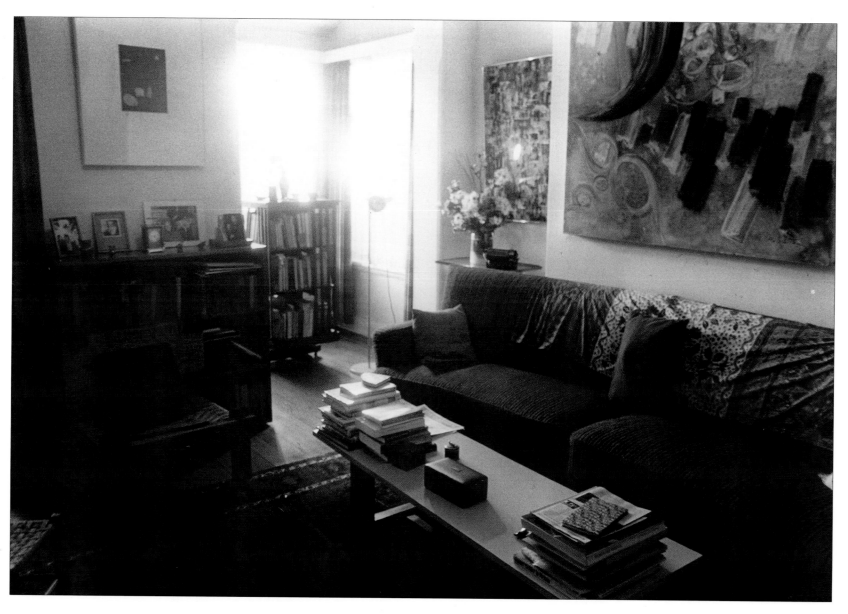

The Living Room a few days after he died. Martin Road. 1990.

AFTER HIS DEATH

I was in the Blue Mountains staying with a friend who was reading the newspaper at breakfast when he told me that Patrick White had died. I felt my stomach tighten and I thought, 'Oh God, it's happened.'

The poet Robert Gray and I went over to see Manoly. The house seemed large and empty without Patrick there. Manoly told us that Patrick had a lung condition, emphysema and asthma, and during the last few days his struggle for breath seemed to fill the whole house.

Patrick had requested that his ashes be scattered in a lake in Centennial Park and Manoly had asked Barbara Mobbs, Patrick's agent, if she would go with him for moral support when he performed the deed the next day, at dawn.

While we were there, Kerry Walker called in to see if Manoly was okay. She'd just come from the Wharf Theatre where she was performing *Rome Tremble*, playing the role of Maria Callas' mother. She still had her make-up on. The two Greeks sat on the couch and it seemed bizarre, like a scene out of one of Patrick's plays.

Patrick had also requested that there be no funeral and that the death not be announced until a week after he died. No one had thought to tell this to the funeral director who sent his usual list of people to the press. There were obituaries in all the newspapers the day after he died.

Patrick had half his way in that there was no funeral.

Manoly Lascaris and Robert Gray. 1990.

94

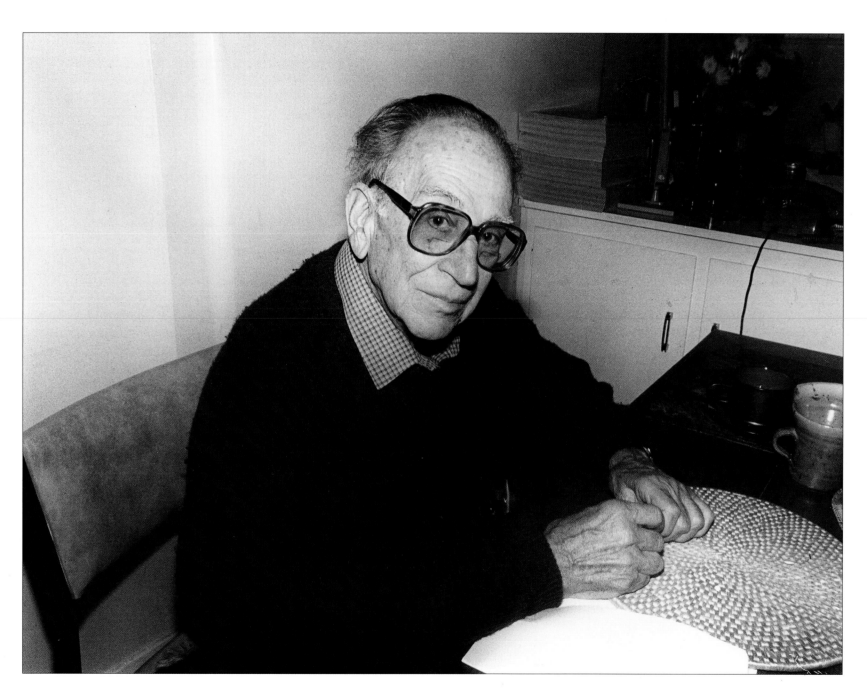

Kitchen, Martin Road. 1990.

DAVID MARR'S BOOK LAUNCH

I think that people need some sort of social ritualisation after a death, especially the death of a celebrity like Patrick White, otherwise the grief is never expressed or resolved.

Less than a year later, the launch of David Marr's biography, *Patrick White: A Life*, by Random House, was regarded by many as the unofficial wake. So we gathered at the Art Gallery of New South Wales as, someone said, 'friends and foes alike,' at an event Patrick would probably have hated.

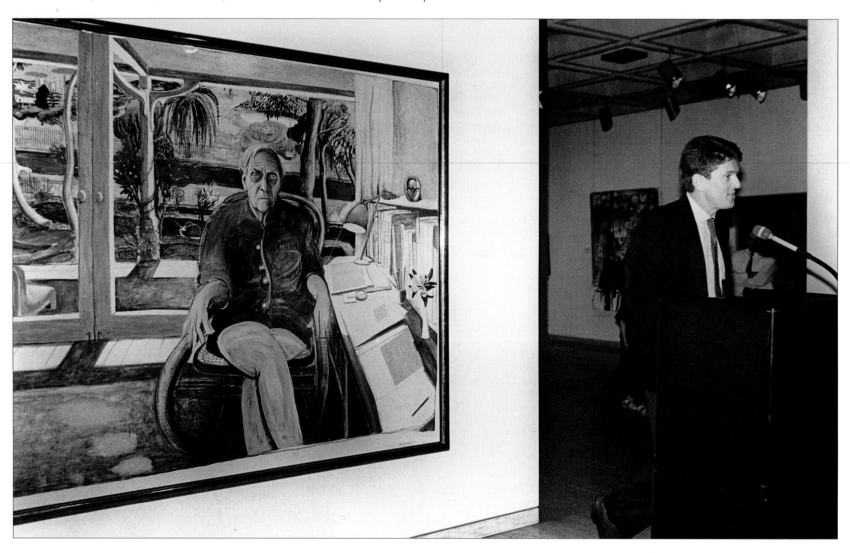

David Marr at his book launch.

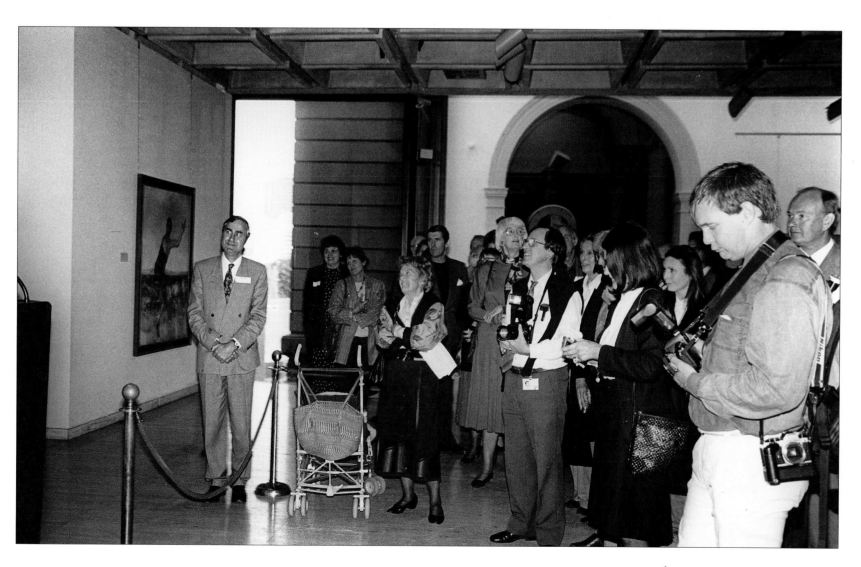

Art Gallery of N.S.W. 1991.

DAVID MARR'S BOOK LAUNCH

Kate and Joe
Fitzpatrick

James
Fairfax

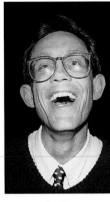

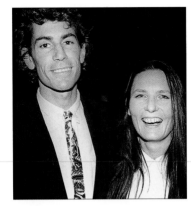

Jim Waites
Lorrie Graham

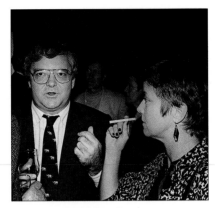

Nicholas
Pounder

Brian Toohey
Elizabeth Wynhausen

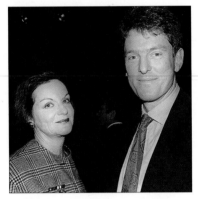

Margaret Fink
David Marr

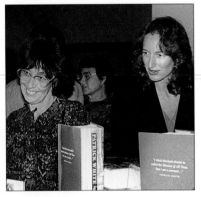

Jill Bailey Janet
Hawley

Jill Hickson John Cody

Brett Whiteley.

Frank
Walters

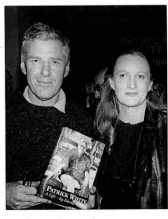

Peter Kingston
Elizabeth Knight

Thea
Wardell

Arthur
Dignam

Jim Sharman

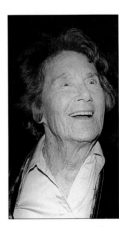

Elizabeth
Riddell

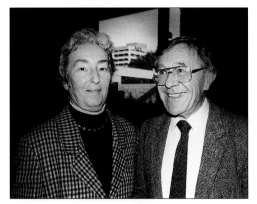
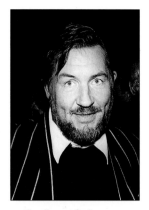

Hannah & Ferry
Grundseit

Tom Uren

Peter Collins

Peter Blazey

Maria
Prerauer

Penny Chapman
Mary Valentine

Barbara
Mobbs

Sue Du Val

Leo Schofield
Ted Marr.

Ken Williams, Dom Maunsell,
Rev. Robert Withercombe.

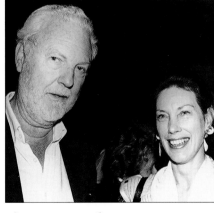

Michael
Fitz James

Kerry
Walker

Barry Oakley
Caroline Lurie.

Margaret
Whitlam

Len, Vita and Neil Armfield

MANOLY ALONE

Patrick had never discussed finances with Manoly who had his own income. When, in those last weeks, Patrick was very sick and required twenty-four-hour attention from nurses at home, Manoly worried if they could afford it, if there was enough money to pay the bills. He had to ring the Perpetual Trustees to make sure they weren't overspending. After Patrick died he discovered that the estate was worth six and a half million dollars. None of which was left to him.

Patrick provided for Manoly, in that he can live in the house for the rest of his life, but after his death the house is to be sold, and along with the rest of the estate, divided among the beneficiaries — the State Library, the Art Gallery of New South Wales, the Smith Family and the Aboriginal and Islander Dance Theatre.

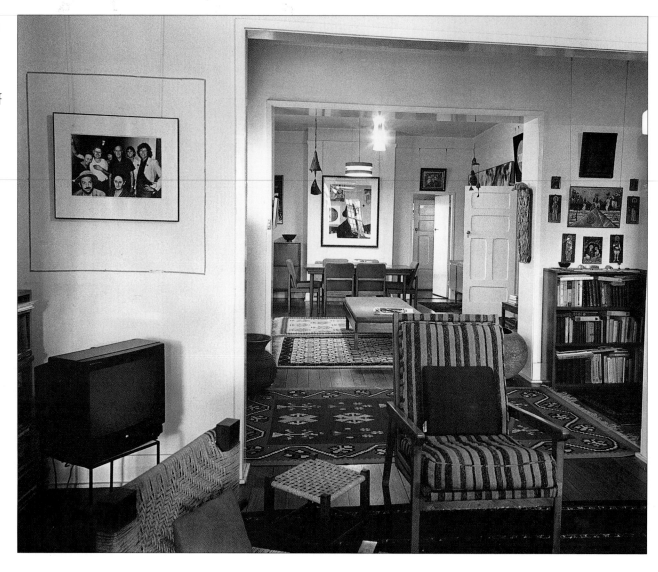

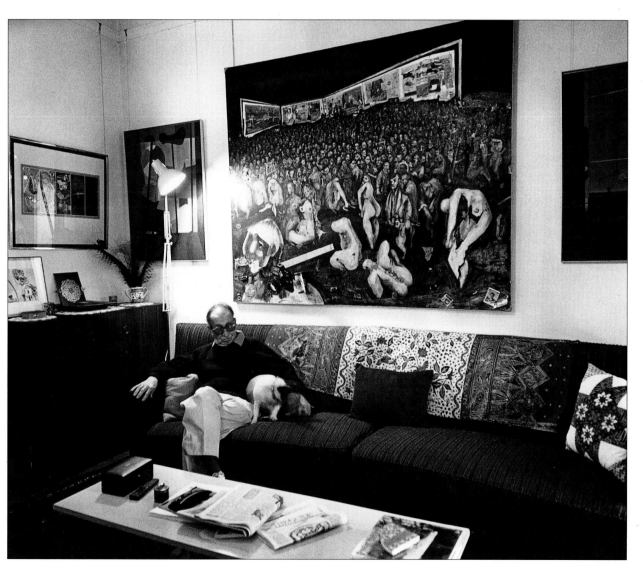

Living Room, Martin Road. 1990.

EPILOGUE

He had always been an Australian legend, but after he died he became mythical.
He lived in people's imagination.
In some ways, Patrick White is more alive now than he ever was.

102

William Yang. 1995.